IMAGES
of America
NEW YORK CITY
FIREFIGHTING
1901–2001

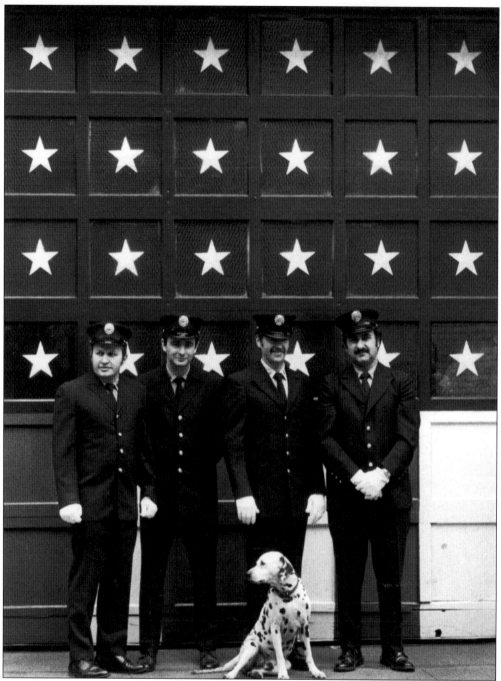

The real stars of this story are the members of the FDNY.

IMAGES
of America

NEW YORK CITY
FIREFIGHTING
1901–2001

Steven Scher

ARCADIA

First printed in 2002.

Published by Arcadia Publishing,
an imprint of Tempus Publishing, Inc.
2A Cumberland Street
Charleston, SC 29401

Printed in Great Britain.

Library of Congress Catalog Card Number:

For all general information contact Arcadia Publishing at:
Telephone 843-853-2070
Fax 843-853-0044
E-Mail sales@arcadiapublishing.com

For customer service and orders:
Toll-Free 1-888-313-2665

Visit us on the internet at http://www.arcadiapublishing.com

Author's Note

I wish to acknowledge the contribution of honorary Chief of Department Jack Lerch and Battalion Chief Jack Calderone and their pioneering work *Wheels of the Bravest*.

CONTENTS

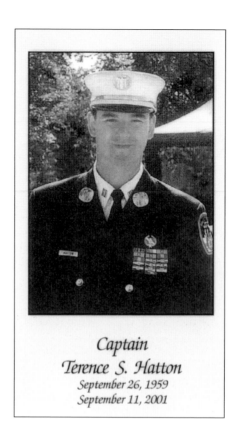

Captain
Terence S. Hatton
September 26, 1959
September 11, 2001

To Captain Hatton and all the others.

INTRODUCTION

New Yorkers in the 18th and 19th centuries had a real romance with firefighting. The volunteer firemen, selected by the General Assembly for being "able, discreet, sober men," were an elite group and enjoyed an elevated status. Each volunteer company had a piece of apparatus individually named, painted, and funded by a group of financial patrons. Ballads were often written about their exploits.

When the cry of "fire!" echoed through the streets of early New York, relaying the alarm from block to block, residents of the closely packed wooden houses would toss the leather buckets they were required to have out their windows to the brigades of volunteer firefighters below. The buckets would be gathered by the volunteers as they ran to the scene of the fire. Other volunteers would race dozens of blocks to the fire, pulling fire pumpers with such affectionate names as Old Brass Backs, the White Ghost, and Red Rover.

Much value was placed on getting "first water" on a fire. Competition and pride among the various volunteer companies was intense. Different companies often collided on the way to a fire, and brawls sometimes prevented any water from reaching the flames. Out of this tradition of bravado and teamwork, the paid New York Fire Department was born in 1865.

The paid department was to be governed by a board of commissioners. The four commissioners (Martin Brown, Philip Engs, James Booth, and Charles Pinckney) had a fire department consisting of 13 chief officers and 552 other members. They worked a continuous tour of duty, with three hours a day for meals and one day off a month. Firefighters were paid $700 a year. The chief engineer (an early name for the chief of department) made $3,000. Horses to draw the apparatus, steam engines, and a telegraph system were quickly put in place. Elisha Kingsland was appointed the first chief engineer. After a reorganization in 1866, a military man, Gen. Alexander Shaler, was named president of the board of commissioners. His reorganization of the department was modeled after the military, a model that stands to this day.

In 1898, the areas around Manhattan were consolidated into the New York City we know today. All of the smaller separate fire departments with their own personnel, equipment, and telegraph alarm offices became one: the Fire Department of the City of New York (FDNY).

In 1901, New York City was only three years old. Although much larger, the city and its fire department had not changed too much. Steam fire engines and wooden aerial ladder trucks were still pulled by horses. Telephones had been in use for two decades, but the department still relied on telegraph and bells for alarms. The photographic images of the first few years of the 20th century give us a good idea of what the FDNY looked like in the late 19th century as well.

One
1901–1939

The fire department was in transition at the beginning of the 20th century. Horses, gaslights, wooden aerial ladders, and ornate helmets characterized the FDNY in 1901. By the 1940s, the department and the city had grown—not outward, as in the late 19th century, but upward. Early skyscrapers, such as Rockefeller Center and the Empire State Building, began to redefine the New York skyline. Subways and the addition of millions of residents made for some interesting years for the FDNY as well.

In 1901, Fire Commissioner John J. Scanell, having been appointed by Mayor Robert A. Van Wyck, found himself with a fire department of 1,400 firefighters. However, the FDNY had to protect one and a half million people and 252 square miles more than it had just three years before. Because of consolidation, Scanell assumed the responsibility of 20 previous officials. Assisting Scanell in rapidly expanding the functions of the department was Chief of Department Edward F. Croker, who served until 1911.

In February 1904, the department showed its spirit of cooperation and bravado by responding to the conflagration of downtown Baltimore, a response of 185 miles.

Fires in the early 20th century were the impetus to improve techniques and equipment. The excursion ship *Slocum* burned on June 15, 1904, killing 1,021 people, a magnitude that would stand for the rest of the century. On March 24, 1911, the Triangle Shirtwaist Company fire killed 146 workers, mostly young girls. This fire resulted in labor and fire safety laws being enacted. In 1912, a fire in the Equitable Life Building killed six and caused the FDNY to begin thinking about fires in high-rise buildings.

In 1909, the department began experimenting with motorized apparatus and, in 1913, with radio (to communicate with the fireboats). Fire apparatus was not uniformly painted red until c. 1915–1920.

By 1939, there were some 10,000 firefighters in the department. The city's population had reached seven million. The influence of vast numbers of diverse immigrants to the city, the disappearing manufacturing economy, and the destruction of whole neighborhoods for a highway-construction project were the seeds of a future that would keep the FDNY busy years later.

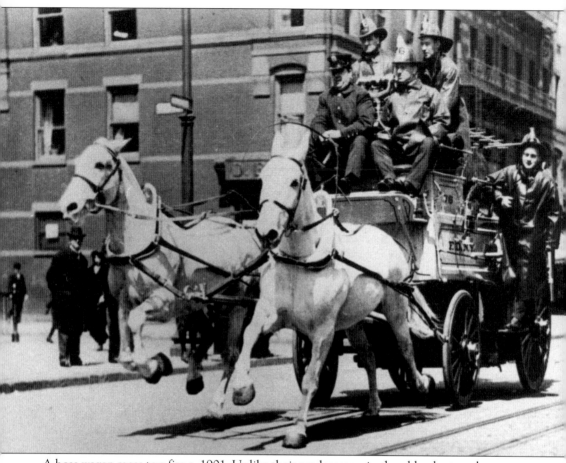

A hose wagon races to a fire c. 1901. Unlike their predecessors in the old volunteer department, these firemen get to ride on the apparatus. The volunteer firemen had to run alongside their rigs to the fire. To this day, when a New York City firefighter answers an alarm, he is "on a run."

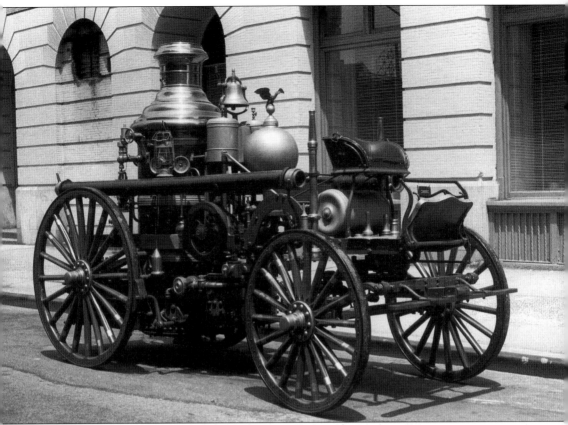

Pictured is a typical steam engine used by the FDNY. The rig was horse-drawn. The steam built up by the boiler provided the pressure to operate the pump, drawing water from a hydrant and feeding a hose line.

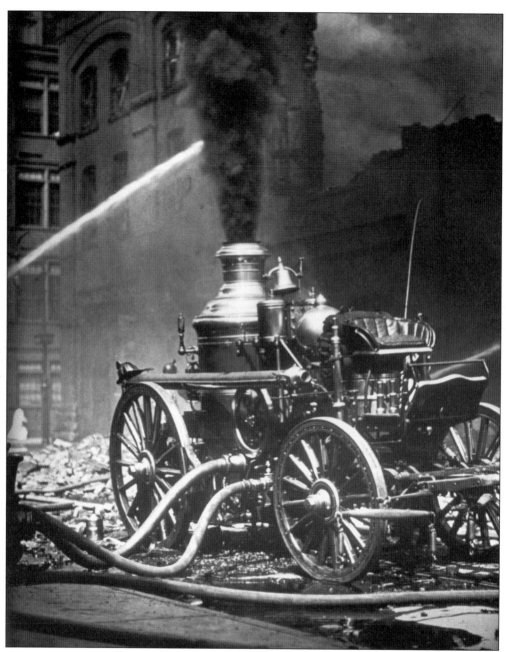

A steamer operates during a fire. At prolonged fires, the horses were unhitched and often brought back to the firehouse. A small fire was always kept up under the steamer's boiler while it was in the firehouse to get a head start in achieving operating pressure. The firefighter who kept the fire up was called the stoker.

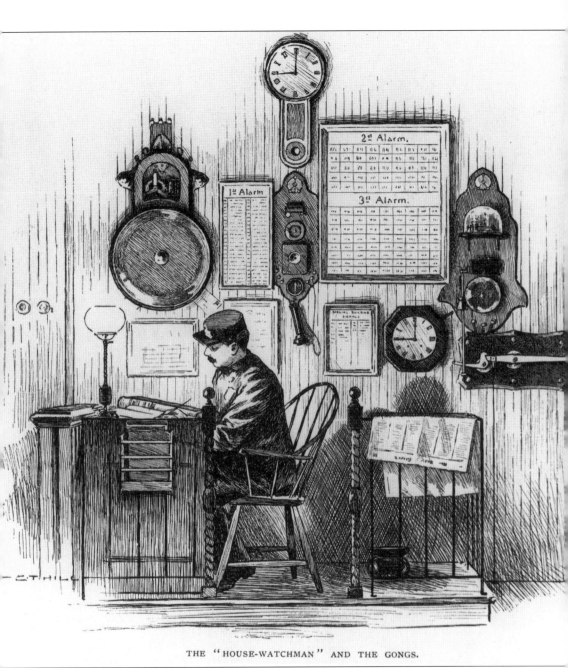

THE "HOUSE-WATCHMAN" AND THE GONGS.

The housewatchman was the firefighter assigned to turn out the company. When an alarm came in, one of the two clocks would stop (thus recording the exact time) and the rod extending from the bell would release the overhead harness so the horse could be quickly hitched. The horses were trained to step out of their stalls and remain under the hitch. The whole turn-out operation could be done in less than 30 seconds.

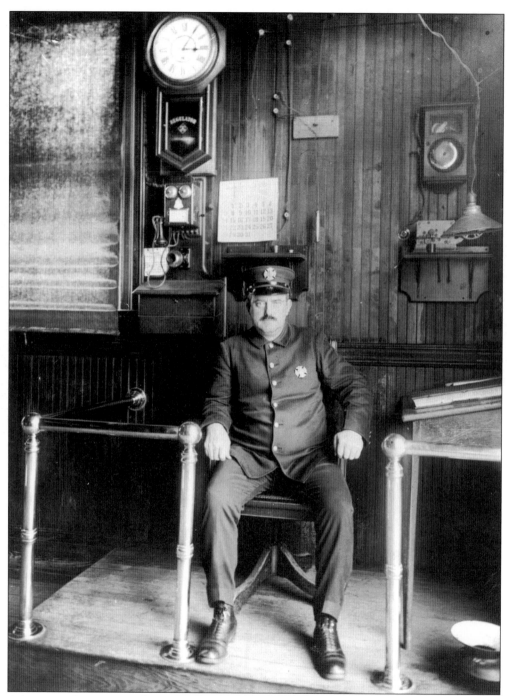

A housewatchman sits at his station. Notice the polished-brass railing and the spittoon. The device under the bell would record the number of bell strokes on a paper tape, denoting the location of the alarm.

The position of the hanging horse hitch can be seen in this view of the housewatch. On the wall is a board listing the assignments of the firefighters and the alarm boxes to which each company was due.

This obviously posed image from May 1904 shows the brass pole in action. Note the telephone, the steam radiator, and the chart showing which companies respond on each alarm up to a fifth alarm. The chair is reinforced so the housewatchman can lean back without the chair collapsing.

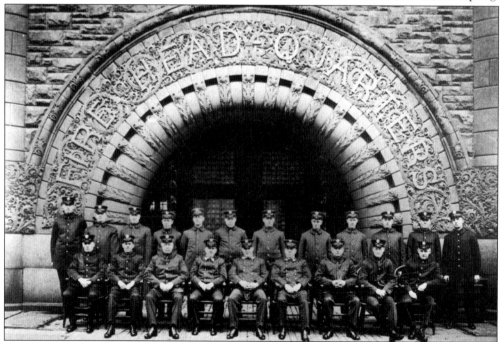

In 1898, Brooklyn became one of the five New York City boroughs. It had its own fire headquarters on Jay Street, and many posed photographs were taken in front of the ornate entrance.

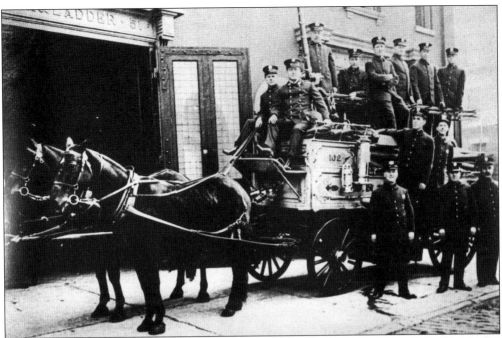

A hose wagon is pictured in 1903 in front of its quarters with its crew. The officer is the firefighter with the double row of buttons on his coat. Part of the street's Belgian block pavement can be seen to the right. To this day, many New Yorkers loosely describe the old Belgian block streets as cobblestone.

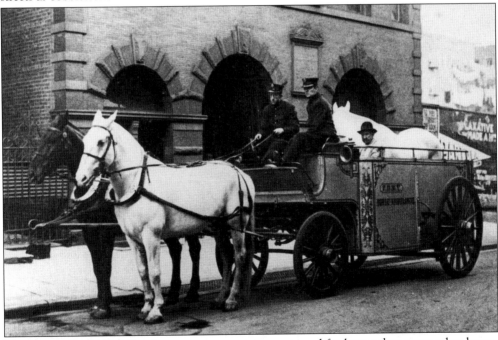

The horses that pulled fire department apparatus were cared for better than most other horses in the city. This wagon was used as an ambulance for the horses. Department regulations required that each horse on the job be given a name rather than a number.

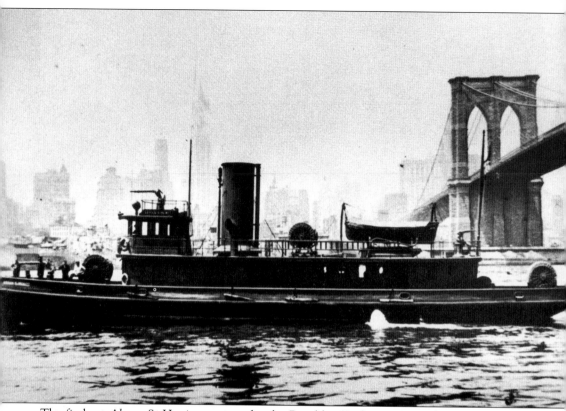

The fireboat *Abram S. Hewitt* passes under the Brooklyn Bridge *c.* 1903. The boat was part of what became a fleet of 10 marine companies that protected the harbor. Named after a New York City mayor, the boat could pump 7,000 gallons of water per minute.

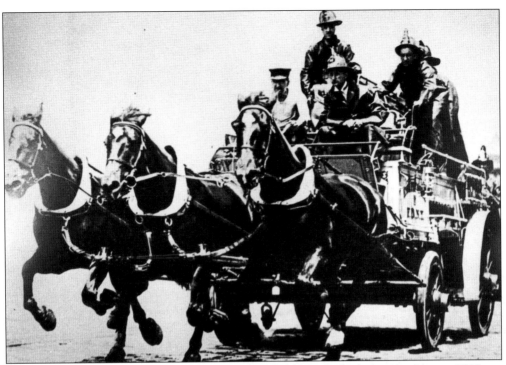

A team of three horses pulls a wagon fitted with a ladder and a high-pressure hose *c.* 1909.

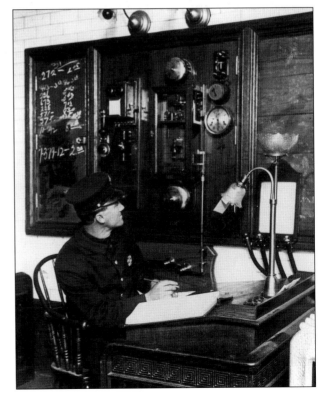

In this view of a housewatchman, the horse trip rod is visible extending from the bell set. The blackboard was to record incoming alarms and their times. The bell set consisted of primary and secondary bells and a telegraph key and sounder. It was custom made for the FDNY by Frederick Pearce, a local electrical manufacturer.

Watching a fire being fought has always held a fascination for many New Yorkers. Some firefighting enthusiasts organized their hobby, and some received a badge like the one pictured. The department gave the badge to journalists, politicians, and other groups. Below, some buffs watch firemen at a Coney Island amusement park fire c. 1912.

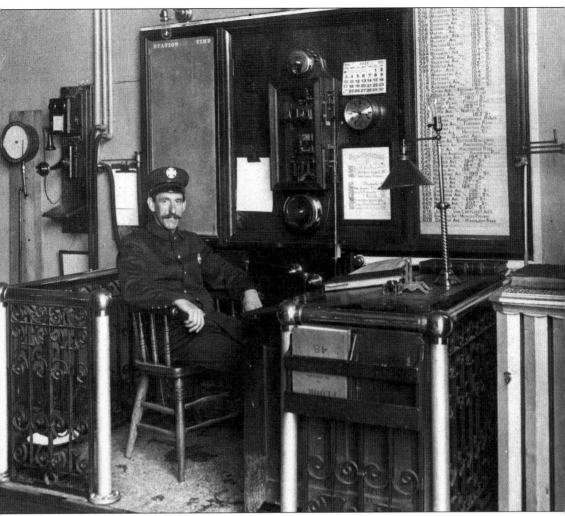

A housewatchman is pictured in 1910 at Engine Company 48, in the Fordham section of the Bronx. On the wall is a list of the fire alarm box locations where Engine 48 was due to respond. Also present is the ubiquitous spittoon.

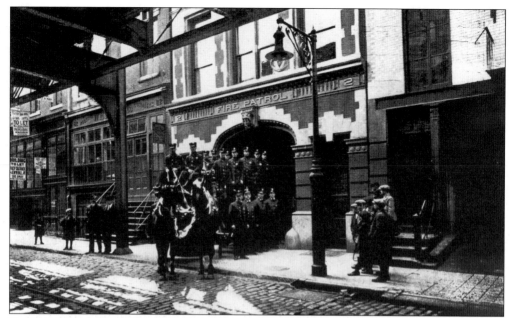

Fire Patrol 2 was located on West Third Street in Greenwich Village. The New York Fire Patrol was privately funded by insurance companies to salvage and prevent damage to commercial property during fires. The work was dangerous, and patrol members have been killed in the line of duty. At one time, there were 10 patrol units in the city.

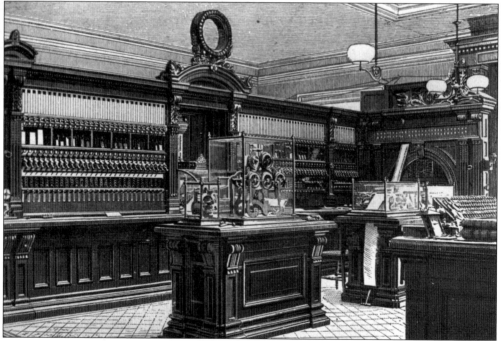

This c. 1900 view shows the fire alarm telegraph office for Manhattan. Each of the five boroughs had its own office. They were equipped with devices to receive alarms and transmit signals to the firehouses by bell and telegraph. Through a series of punched holes, tape registers recorded the alarm box number that had been pulled on the street.

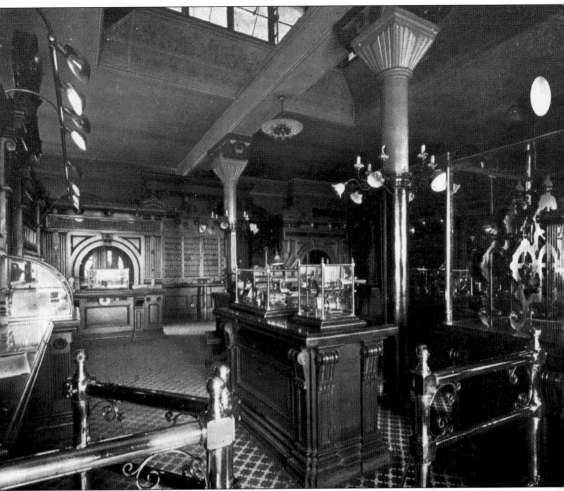

By 1910, the Manhattan fire alarm telegraph office had evolved into a showplace of technology, with instruments made of bronze, enclosed in glass, and mounted on oak and mahogany bases. Tiled floors and polished-brass railings completed the picture. Visitors were encouraged to come see this marvel. Note the light fixture, which was equipped to use either gas or electricity. At the time, it was still unsure which utility would prevail, so lights were made that could run on either.

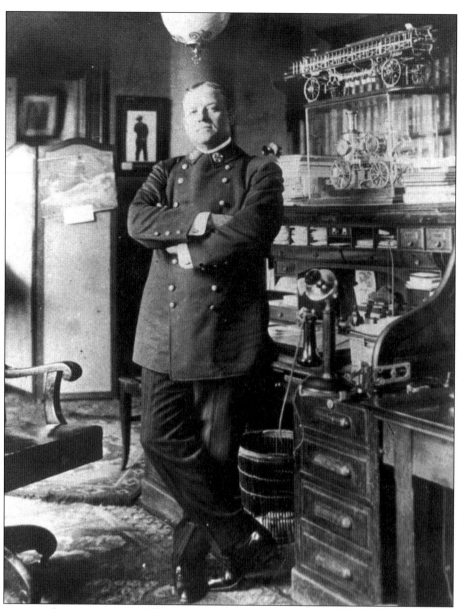

"I have no ambition in this world but one, and that is to be a fireman. The position may, in the eyes of some, appear to be a lowly one; but we who know the work which a fireman has to do believe that his is a noble calling. There is an adage which says that 'Nothing can be destroyed except by fire'. We strive to preserve from destruction the wealth of the world, which is the product of the industry of men, necessary for the comfort of both the rich and the poor. We are the defenders from fire, of the art which has beautified the world, the product of the genius of men and the means of refinement of mankind. But, above all, our proudest endeavor is to save lives of people—the work of God Himself. Under the impulse of such thoughts, the nobility of the occupation thrills us and stimulates us to deeds of daring, even at the supreme sacrifice. Such considerations may not strike the average mind, but they are sufficient to fill to the limit our ambition in life and to make us serve the general purpose of human society." —Edward F. Croker, chief of department from 1899 to 1911.

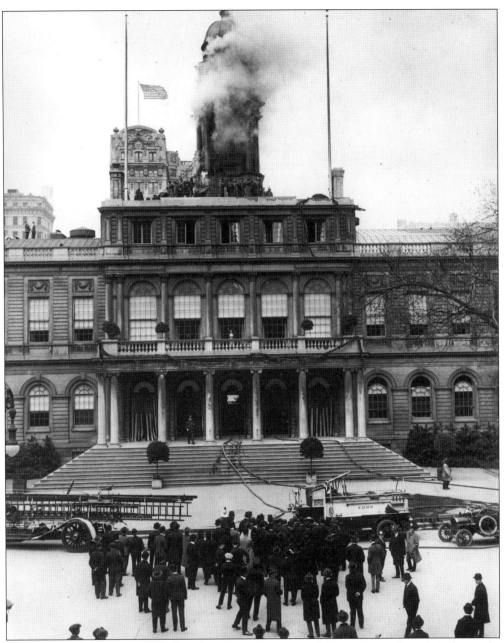

This 1911 city hall fire was believed to have been started by a pigeon that picked up a lit cigarette and brought it to its nest in the tower. All the spectators are men, and each is wearing a hat. Some of them have press cards in the hatbands. Designed by McComb and Mangin in 1802, the building is still considered one of the most beautiful city halls in the country. The city's first fire alarm telegraph office was located in its basement.

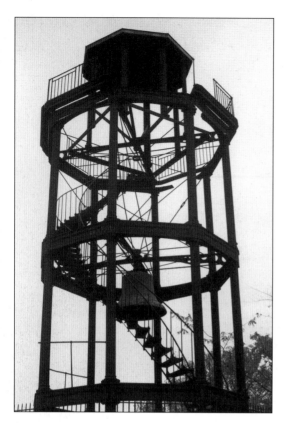

In the mid-19th century, several bell towers like this one were erected around the city. The watchman who was stationed at the top would telegraph the location of fires to the central telegraph office. The office would then dispatch the appropriate fire companies, also by telegraph. The bell was electrically operated from the central office. The number of strokes heard on the bell indicated the nearest fire alarm box to the fire. This is the only remaining tower, located in Harlem's Marcus Garvey Park.

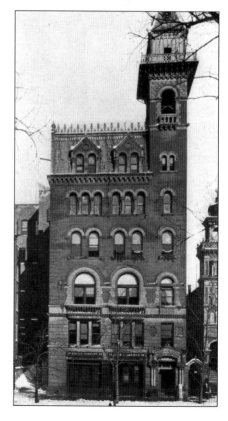

This building served as headquarters of the FDNY from 1886 to 1914. The 1910 fire alarm telegraph office was located on the top floor. On the ground floor were (and still are) Engine Company 39 and Ladder Company 16. The building still stands, albeit without the watchtower.

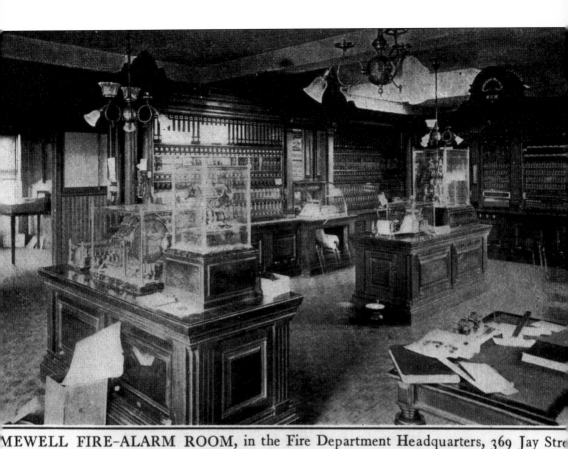

MEWELL FIRE-ALARM ROOM, in the Fire Department Headquarters, 369 Jay Stre
pment furnished by the Gamewell Fire-Alarm Telegraph Co., by which instant and definite notice of
signalled. This efficient service saves annually millions of dollars of property, and incalculable lives.

New York's fire alarm telegraph offices were showplaces of technology, and the Gamewell Fire
Alarm Telegraph Company frequently featured views of the offices in its publications and
advertising. Pictured here is the Brooklyn office.

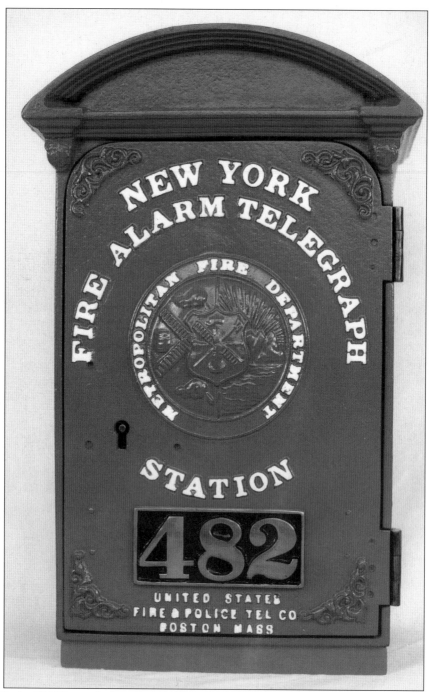

In 1870, the FDNY installed street fire alarm boxes on telegraph poles south of 14th Street. The fire alarm box had been invented by Dr. William Channing years earlier. Channing was a physician and fire buff who devised a system of a revolving coded-wheel mechanism that would open and close a telegraph circuit. Each fire alarm box was assigned a number, and the central office knew what location corresponded to each number. The 1870 box, shown on these two pages, required a key to access the mechanism and send in the alarm. Storekeepers, firemen,

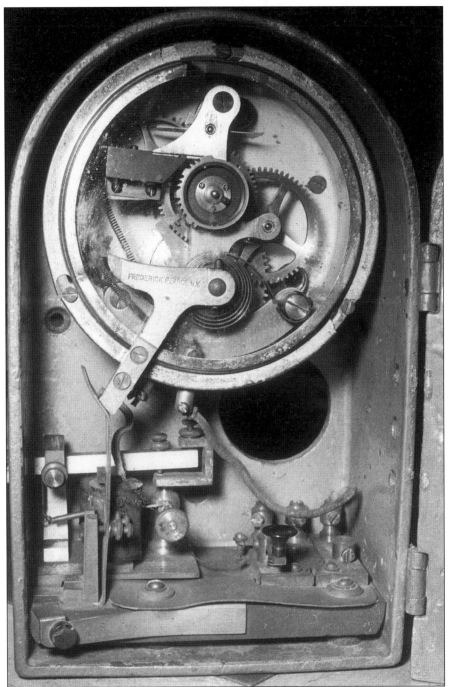

policemen, and select citizens had the keys. The seal seen in relief on the door is that of the Metropolitan Fire Department of 1865–1870. Because New York State then controlled the department, the seal shows elements of both the New York City and New York State seals. Because of the locked-door feature, some of these boxes survived in public schools into the mid-20th century. In the view of the inner mechanism, we see the coded wheel as well as a telegraph key and sounder, which the chief would use to communicate with the central office.

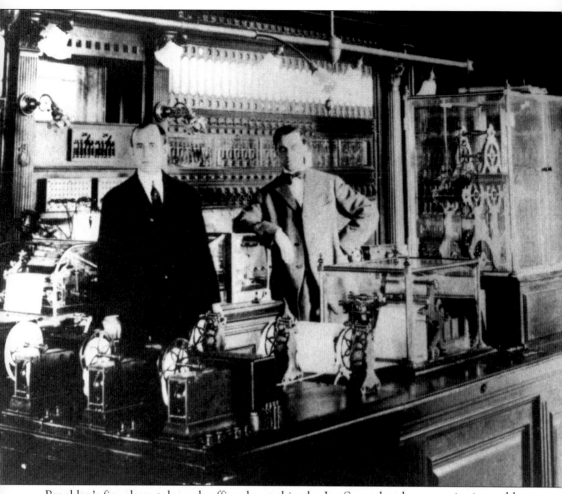

Brooklyn's fire alarm telegraph office, located in the Jay Street headquarters, is pictured here. Workers in the fire alarm offices were professionals and dressed the part. Note the multiple punch-tape registers, which recorded the incoming alarm box numbers on different circuits.

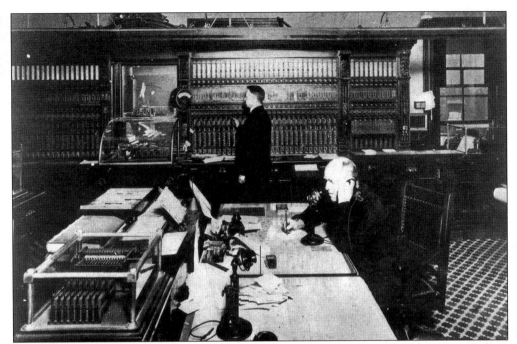

This view of Manhattan's fire alarm telegraph office dates from c. 1914. Note the prominence of the telephones. The dispatchers are still wearing suits, but the office itself has begun to lose the ornateness seen in previous offices.

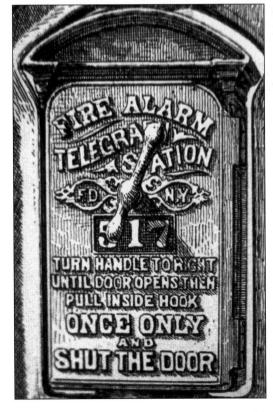

By the early 20th century, most fire alarm boxes had been changed to this keyless type. Any citizen could simply turn a handle to open the outer door and, by pulling an inner lever, call for help. Although it allowed for false alarms, the keyless door meant less delay in reporting a fire.

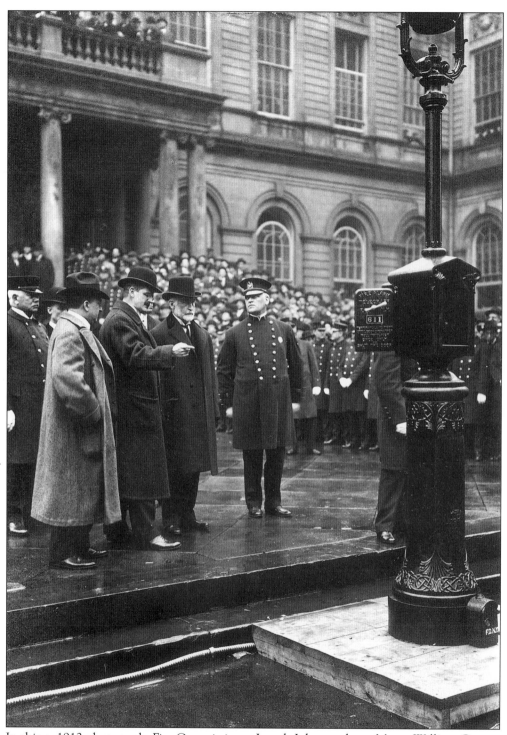

In this *c.* 1912 photograph, Fire Commissioner Joseph Johnson shows Mayor William Gaynor a newly designed fire alarm post. The post was set up and wired in front of city hall just for the day, in order to coincide with the department's awarding of medals.

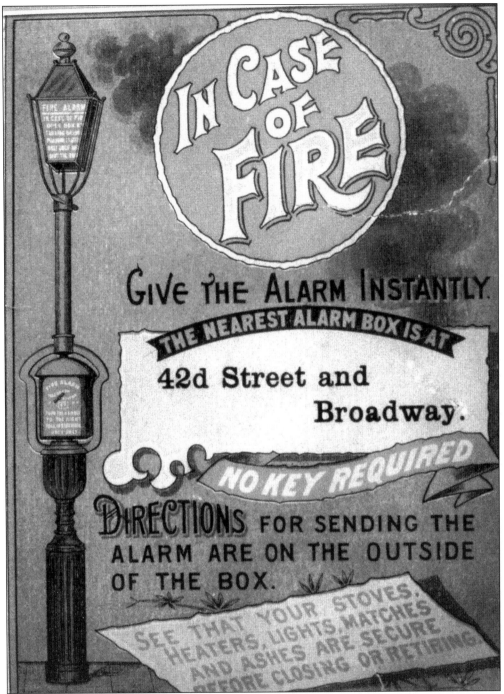

This sign notes that no keys were required to use alarm boxes. The signs were posted in theaters, stores, and offices to direct people to the nearest street alarm box.

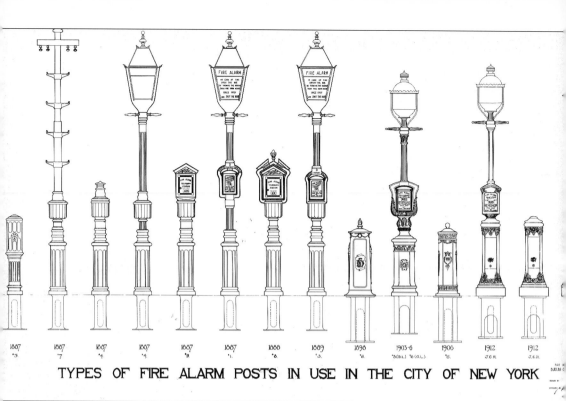

1887	1887	1887	1887	1887	1887	1888	1889	1898	1903-6	1906	1912	1912
*3	*7	*4	*4	*9	*1	*6	*3	*8	*3(O.L.) *6(O.L.)	*6	J.C.R.	J.C.R.

TYPES OF FIRE ALARM POSTS IN USE IN THE CITY OF NEW YORK

In the late 1880s, the FDNY began taking the fire alarm boxes off the wooden telegraph poles and placing them on their own metal posts. The Blizzard of 1888 expedited this by destroying overhead wires on the telegraph poles. The post designs were named after the head of the telegraph bureau at the time. The 1887 post, which was designed to allow the flow of gas to illuminate the lantern atop the post, was the brainchild of Supt. of Telegraph J. Elliot Smith. He made sure his name was cast into every post. The 1912 post was named for Supt. of Telegraph J.C. Rainey.

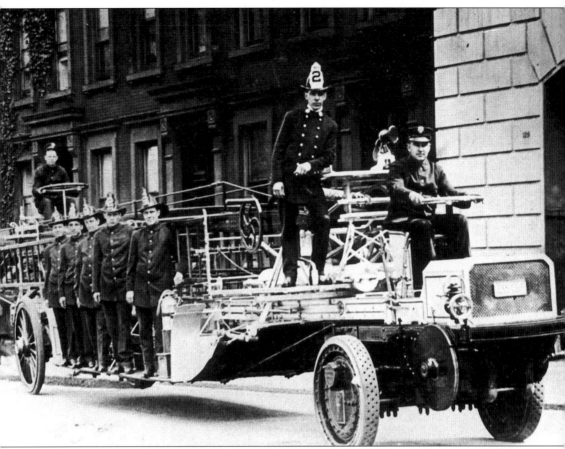

Members of Ladder 2 show off their new motorized rig in 1913. The FDNY had begun experimenting with motorization with a 1909 motorized hose wagon.

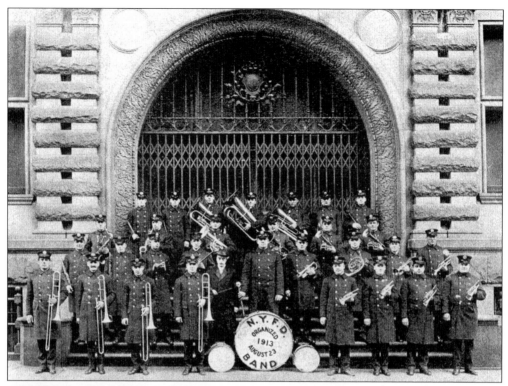

Above is the FDNY Band, organized in 1913 and in existence through the 1950s. To the left is the band's official badge, with a lyre in place of the numbers. The badge features a hook and ladder on the left and a hydrant on the right.

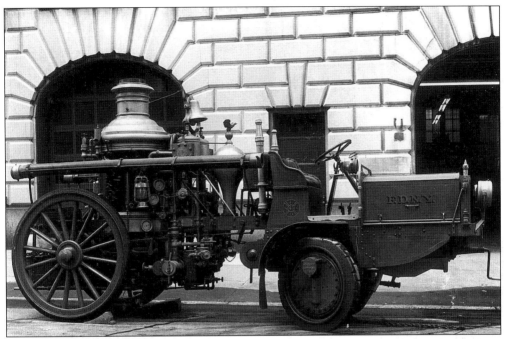

As the department continued with the motorization of its apparatus, a common sight was a horse-drawn rig that was married to a motorized tractor.

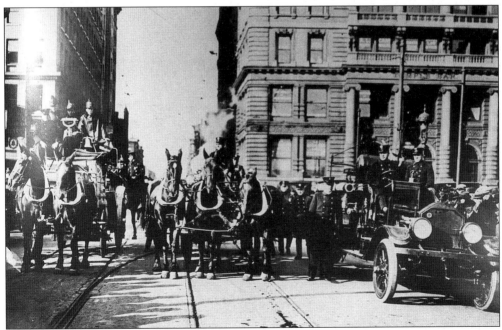

By 1922, the motorization of the department's first-line apparatus was complete. In this view, Engine Company 205 in Brooklyn exchanges its horse-drawn rig for a motorized pumper. It was the last run of the horses.

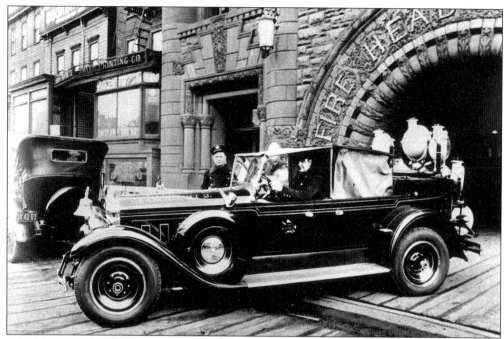

Searchlight Unit 2 shows off its 1929 Packard in front of the old Brooklyn headquarters. This automobile was given to the FDNY by a group of patrons who followed the activities of the department.

Mayor Fiorello LaGuardia is pictured at a fire in 1936. A big fire buff and all-around character, LaGuardia was mayor from 1933 to 1945. He was quoted as saying, "The day is coming when we can reduce fire companies in New York City. With modern fireproof structures, with our great increase in the number and quality of our fire engines, with the advent of training programs, the large fires will become almost a thing of the past, and I can foresee the day when the department is almost cut into half."

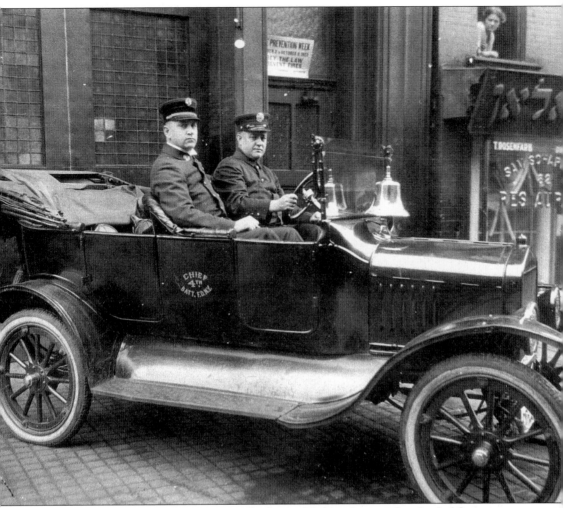

Battalion Chief John J. McElligott poses in his buggy. He later became the chief of department, serving from 1932 to 1940.

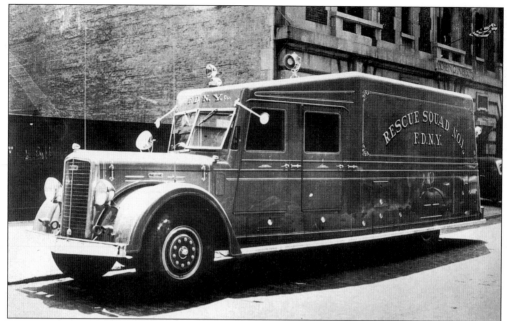

In 1919, the FDNY established a rescue company. It was staffed with firefighters who had special skills, such as construction and engineering. Eventually, there would be five such companies in the city. Pictured in 1939 is the Rescue 1 rig, which was the company's first to be fully enclosed.

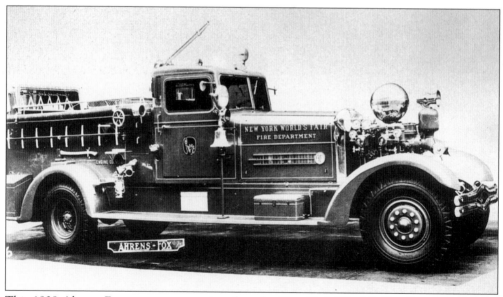

This 1938 Ahrens-Fox pumper was assigned to the New York World's Fair Fire Department. The department consisted of five engines and a staff of firefighters from the FDNY. In their two years of service at the World's Fair of 1939–1940, the department fought one serious fire, at the Kodak pavilion.

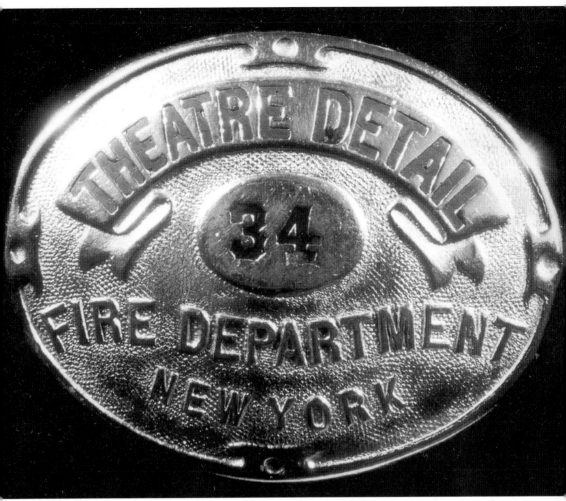

From 1884 through the 1950s, the department would assign a firefighter to Broadway shows. While on duty, the firefighter would wear this badge and monitor fire safety in the theater.

רויבען

איז דא פארבאטען

ונטער שטראף פון געלד, געפענגעניש, אדער ביידע

PATRICK WALSH

FIRE COMMISSIONER and
CHIEF of DEPARTMENT

The FDNY has to work with people of many cultures and backgrounds. This c. 1941 sign reads, "Smoking prohibited," in Yiddish. The fire department has long had a community relations office to work with the diverse citizens of New York City. These signs were posted in theaters, halls, and places of public assembly.

Two
1940–2001

In some ways, the FDNY in 1940 was still getting into the 20th-century technologically. Radios were only used in the fireboats, rescue companies, and by high-ranking chiefs. The engines and trucks did not all have radio capability until 1952. In the second part the 20th century, however, we see the FDNY finally coming into its own.

During World War II, the city and its fire department stood still, acquiring little in new equipment or technology and virtually no new building projects. The FDNY did send a few chiefs to London to observe how their fire department handled blitz-related fires. After the FDNY learned from the visiting chiefs that water supply was a problem in London, it converted some aerial ladder trucks to vehicles capable of carrying miles of hose.

In 1942, the ship *Normandie* was being converted for military use at a West Side pier. It burned and capsized, leading people to suspect sabotage, which was never proven. During the war, FDNY fireboats used secret radio codes with the navy in order to patrol and operate in the harbor unhindered. By the end of the war, a total of 33 fire department members serving in the armed forces had been killed in the line of duty.

The early 1950s saw the installation of two-way radios in every piece of FDNY apparatus, a quantum leap in fire communications.

In 1960, two airplanes collided in the air over New York. One crashed into an open area of Staten Island, but the other crashed into a crowded Brooklyn intersection, killing passengers and pedestrians. Three days later, the same shift of firefighters that operated at the plane crash was called to the Brooklyn Navy Yard to fight a fire on the USS *Constellation*. Fifty workers aboard the ship were killed.

By 1963, the crumbling housing infrastructure and economic conditions caught up with the city, resulting in 200 city blocks being burned to the ground that year. The FDNY acquired its first tower ladder and the Super Pumper apparatus in 1965. In October 1966, while fighting a fire in a commercial building on 23rd Street in Manhattan, 12 firefighters were killed when a floor gave way beneath them. It was the worst calamity to befall the department since its organization in 1865. In 1968, as civil disturbances occurred around the country, the FDNY had to fight hundreds of structural fires, sometimes while being attacked.

The 1970s saw a fiscal crisis in the city, resulting in closed and disbanded fire companies and the elimination of some chief functions and special units. This was occurring while total alarms had gone from 62,000 in 1950 to 400,000 in 1975.

During the summer of 1977, the city suffered its second major power blackout. This incident was uglier than the blackout a decade earlier. Hundreds of fires during the one-day period stretched the department to its limits. In 1980, the first 42 women firefighters became part of the FDNY family.

The 1980s and 1990s saw the department creating special units to deal with emergencies never imagined in the past. Chemical and biological hazards, building collapses, new types of fuels, and terrorism all impacted how the department operated. Although Fire Commissioner Howard Safir once described the FDNY as "one hundred and twenty-five years of proud tradition, unimpeded by progress," the department had no choice but to keep up with the modern world.

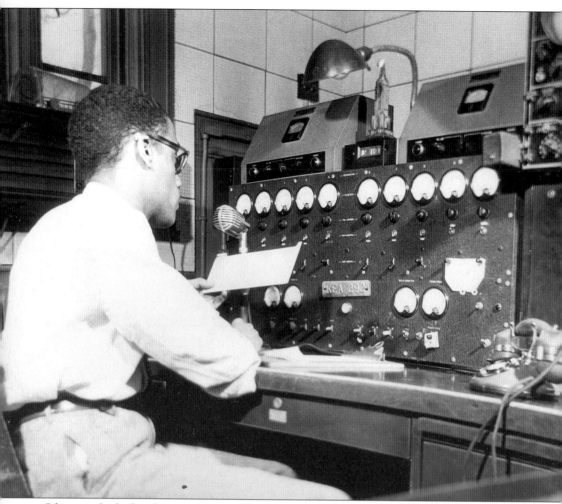

Often overlooked is the importance of how the alarm of fire gets to the department in the first place and how the equipment and personnel are dispatched. In this *c.* 1960 view, legendary dispatcher Russell Ramsey announces an alarm by radio.

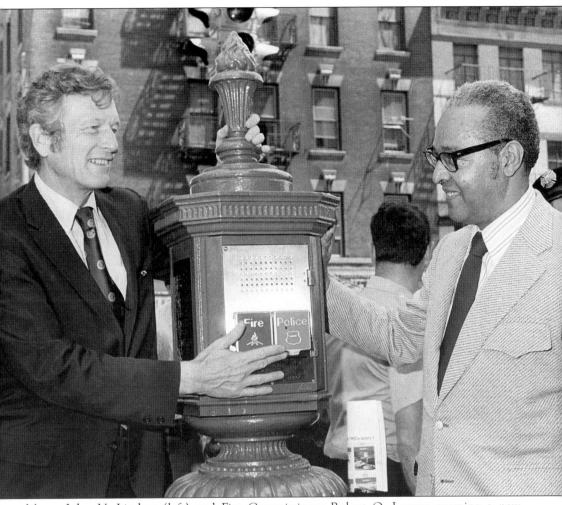

Mayor John V. Lindsay (left) and Fire Commissioner Robert O. Lowery examine a new "talking" fire alarm box in 1973. Although most cities in the United States removed their street alarm boxes because of problems with false alarms and the cost of maintaining such a system, New York City has kept the street boxes. In the late 1990s, the city attempted to remove the boxes, but the dispatchers successfully argued in court that removing them would deprive handicapped and phoneless citizens of a way to get help in an emergency.

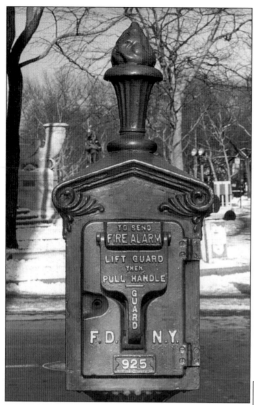

The fire alarm boxes on these two pages were used on the streets of New York during the 20th century. To the left is a 1912 post that can still be found on some street corners. Below is a box designed to match the ornate cast-iron streetlights of Fifth Avenue in the 1930s and 1940s. Some of the posts survive today along the Brooklyn waterfront.

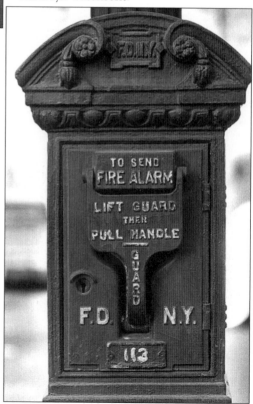

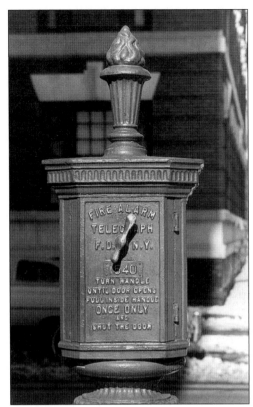

The style of the box to the right dates from the 1930s. Below is a hybrid of a 1912 post and a 1970s box.

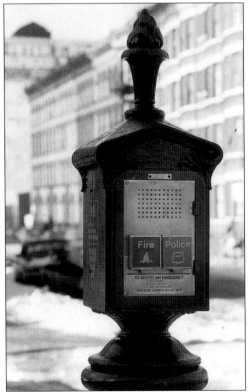

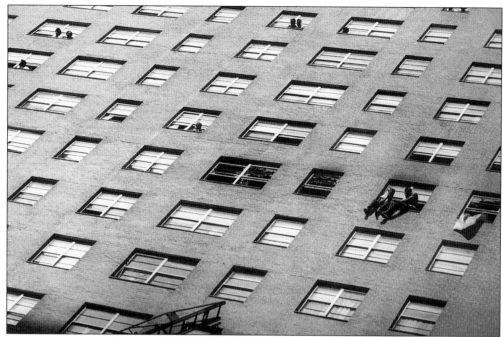

Too high to be reached by any ladder company, residents of a Bronx apartment building await rescue *c.* 1967. Although the buildings were ostensibly fireproof, the contents could burn and fire could spread from one apartment to another.

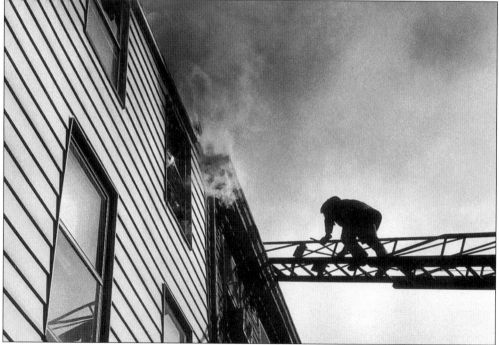

A firefighter ascends to the roof in a Brooklyn house fire in the late 1960s. This was a tricky task on a straight, nearly horizontal ladder. Contrast this approach with the use of the later tower ladders.

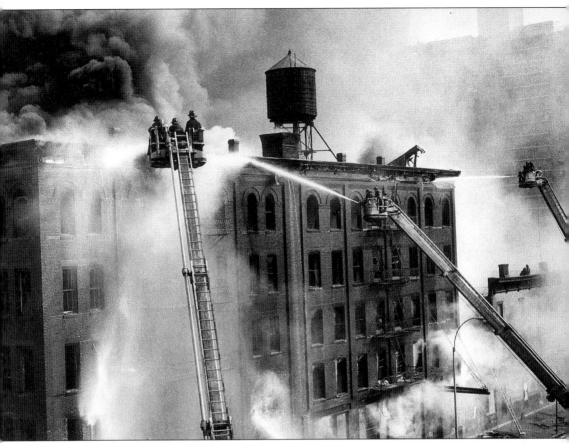

Firefighters battle a Williamsburg factory fire in 1976. Using more than one or two tower ladders indicates that fighting the fire could go on for hours or even days. Note the rooftop water tank, always a collapse potential.

A firefighter on a straight aerial ladder directs a stream of water at a fire in the Bronx *c. 1969*. The photographer was taught by *New York Post* and Brooklyn Dodgers team photographer Barney Stein to "get height" when photographing fires.

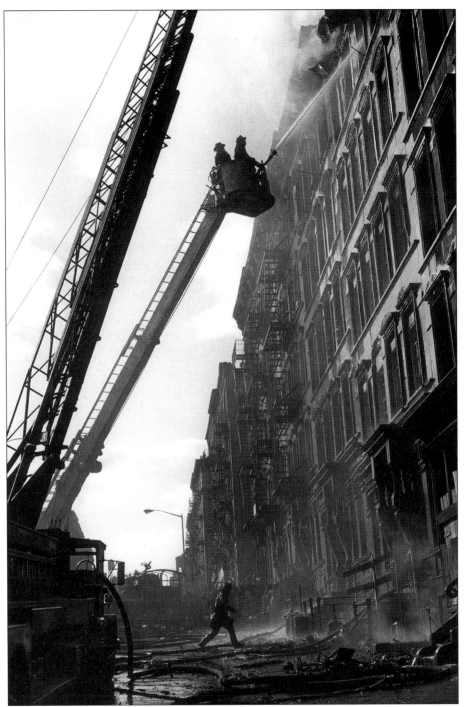

A tower ladder operates at a South Bronx fire c. 1971. The FDNY acquired its first tower ladder (often erroneously called a cherry picker) in 1964. The extendable, maneuverable bucket could hold two firefighters and accurately direct a stream of water into fire high above the street level. Also useful for rescues, the tower ladder revolutionized the way aerial ladders were used in fighting fires. Their use is credited with shortening the time it takes to control a major fire.

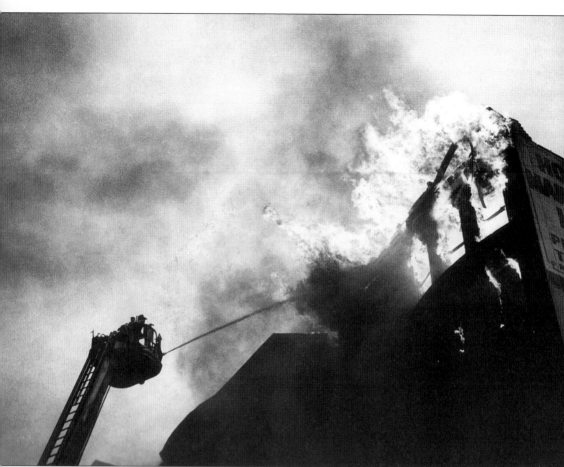

Pictured is a midtown hotel fire. Top-floor fires, particularly in hotels or apartment buildings, are dangerous because of the tendency of the fire to spread and burn through the roof.

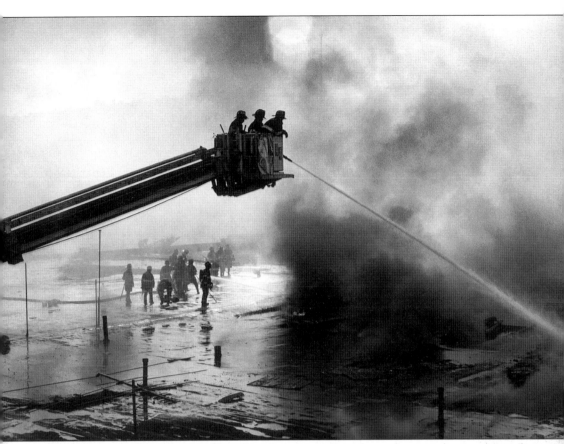

At this Bronx store fire, a tower ladder is being put to good use by getting members to the roof and by providing quick water and an avenue of escape if the firefighters have to bail out.

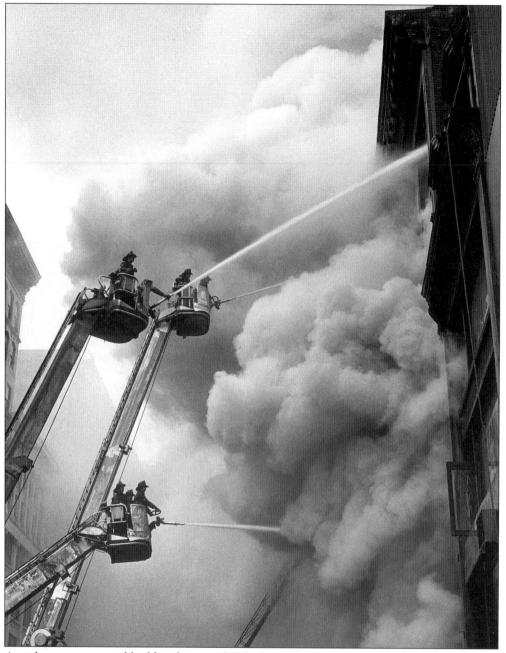

A midtown commercial building burns *c.* 1975. An exterior attack is used when a fire is so out of control that it would be impossible to fight it from inside the building.

Following Barney Stein's dictum to "get height," the photographer captured these firefighters at a Brooklyn fire with the World Trade Center as a backdrop.

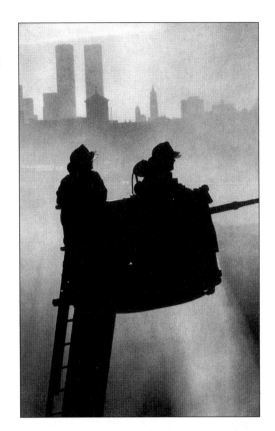

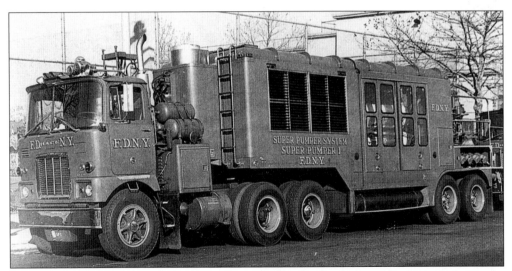

In 1965, the FDNY acquired the Super Pumper. Specifically designed for New York City by William Francis Gibbs, it took three years to build and was described as a "fireboat on wheels." Its pump could feed dozens of hoselines simultaneously and could draw from eight hydrants. It could direct a stream of water three-quarters up the height of the 102-story Empire State Building. The pressure of the water stream from its custom-designed nozzle was occasionally used for hydraulic overhauling (knocking down remaining walls).

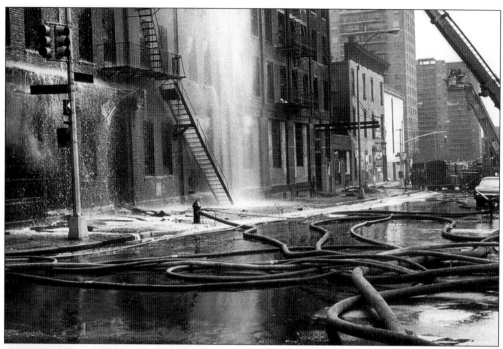

Tens of thousands of gallons of water were needed to extinguish this Brooklyn factory fire. During a fire, the weight of the water and the possibility of collapse become factors in whether the chief will allow interior operations.

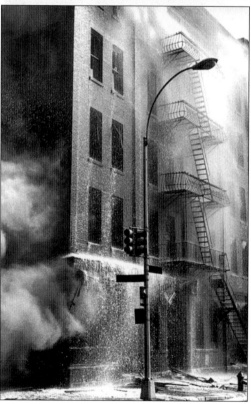

A hydrant operates at a fire. In the early history of New York, water would flow from local reservoirs through hollowed-out wooden mains. When it was necessary, a firefighter would chop a hole in the main. After the fire, the hole would be plugged up—thus the term "fire plug."

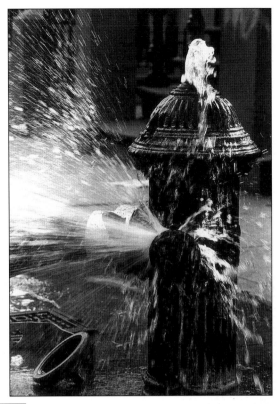

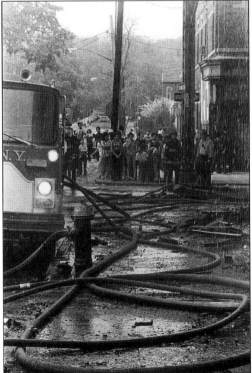

After the fire, it takes a couple of hours to gather up the hose lines. In cases when a hydrant is blocked by a car, the engine's operator may break the car's windows and run the hose through the car. This engine, however, has good access to the hydrant.

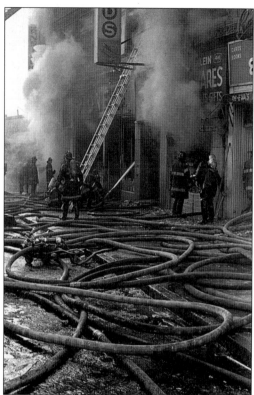

A manifold is shown during a fire. The manifold is a control-valve device that allows six to eight hose lines to be fed from one larger supply line, rather than having the lines stretched from individual engine companies at a distance.

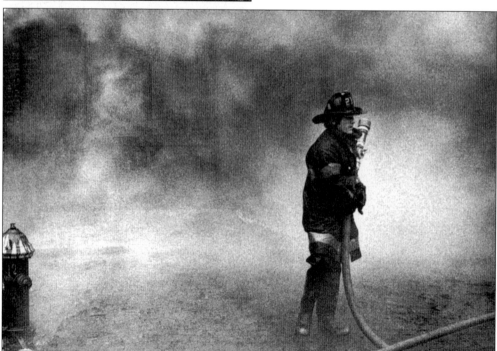

The "nozzle man" has a tough job. Often the closest to the fire, he frequently has to wait for water and then must control a charged hoseline that can fly from his grasp from the water pressure.

Nozzle men are shown in action. During a fire, the nozzle man must know the location of all the other firefighters and aim the stream of water carefully to avoid injuring them, either directly or by pushing the fire toward them.

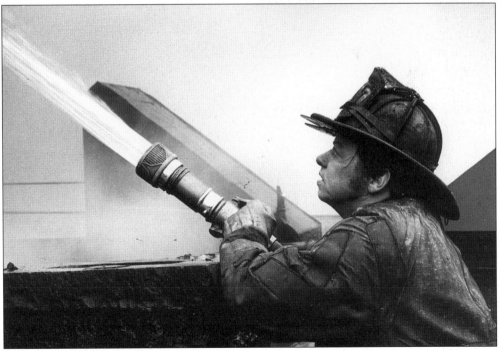

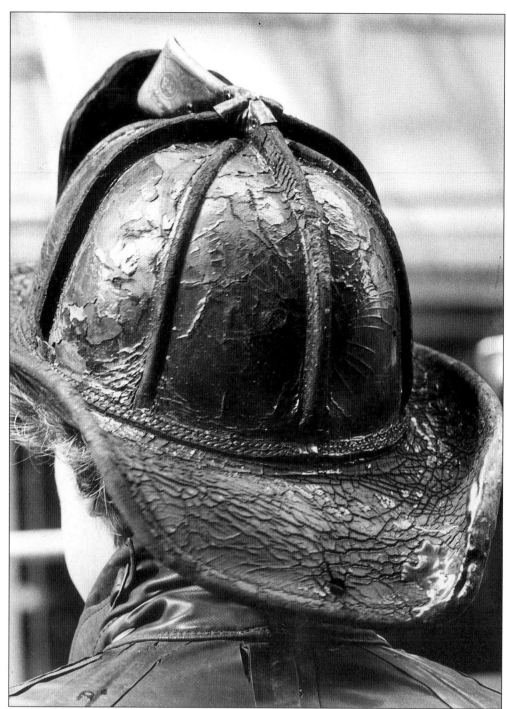

Probably the most sentimental piece of firefighting equipment, the leather helmet is a reminder of all the jobs the firefighter has fought. The heat and dripping hot water in a burning building have produced the cracking of the leather. If tools are unavailable, the helmets can be used to break windows. Before the days of individual radios, a firefighter in trouble on a rooftop could throw his helmet over the side to summon help.

This landmark New York City firehouse, located on Great Jones Street, was designed by Ernest Flagg in 1898. It houses Engine Company 33 and Ladder 9. At one time, the chief of department would use the building as his night headquarters.

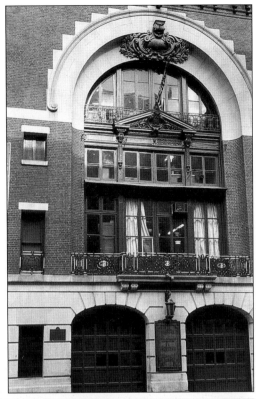

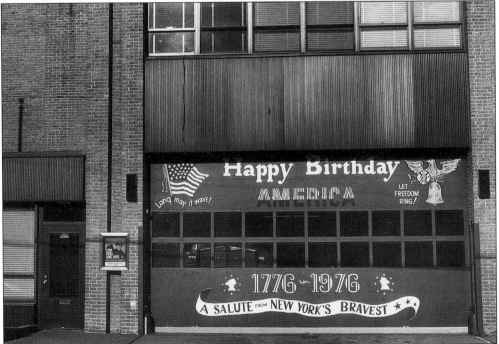

New York City firefighters showed their pride of country during the national bicentennial by painting each firehouse in an individual style. Pictured is Engine Company 63 in the Bronx.

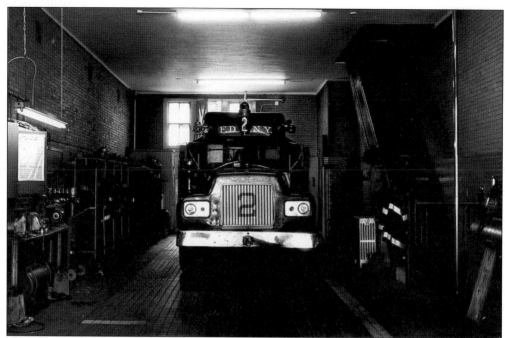

Waiting for the big one is Rescue 2 in its Brooklyn quarters in 1975. The firefighters take care of their rigs as much for pride as for maintenance.

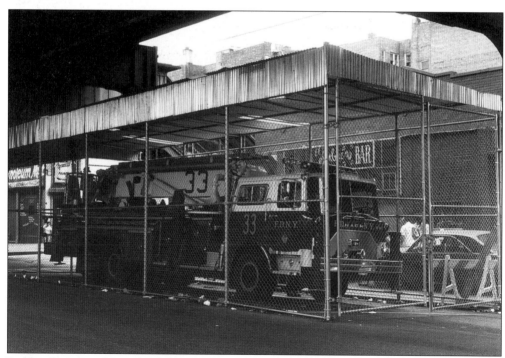

Ladder Company 33 in the Bronx is shown locked in its protective cage while the firehouse undergoes renovation. In this high-crime area, firefighters have to protect their equipment, including the rig itself.

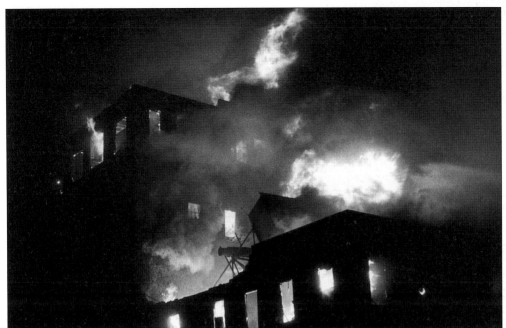

Firefighters have long referred to fire as the "red devil," and the battle against it can become personal. The above fire took place in Manhattan *c*. 1977. To the right is a *c*. 1976 fire in Bushwick, Brooklyn.

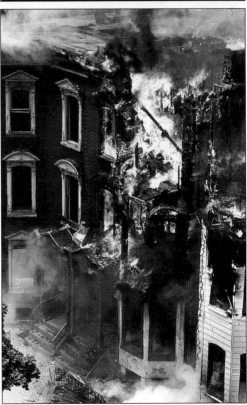

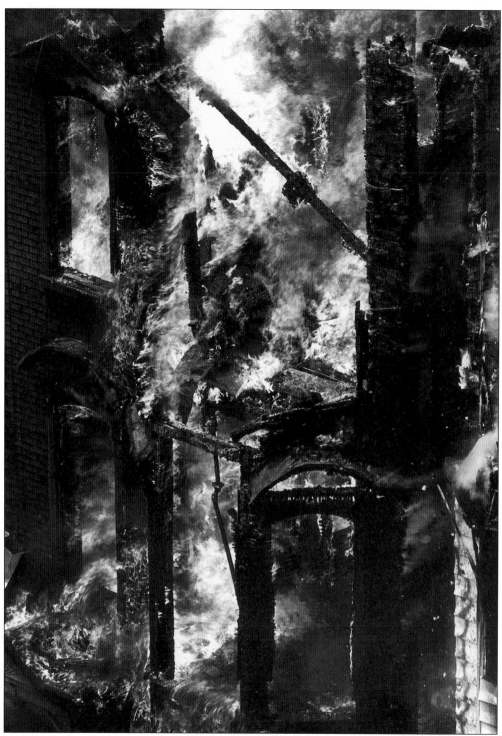

At this point in a fire, a collapse becomes imminent and no one goes inside. This building, vacant to begin with, will shortly be a total loss. If it does not collapse during the fire, the city will demolish whatever remains.

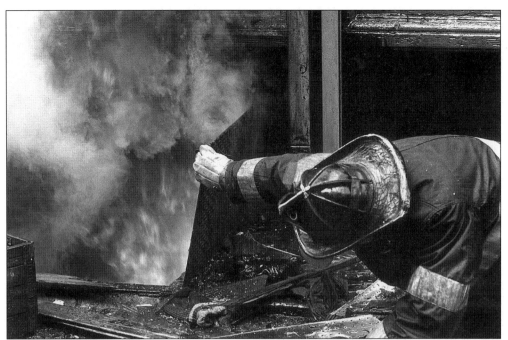

Cellar fires are particularly nasty. The firefighters have no indication if hazardous materials are stored there, and the area is dark and confined, with only one way in or out. The chief in command may try to use foam to smother the cellar fire, which sometimes has the effect of pushing the fire into the rest of the building.

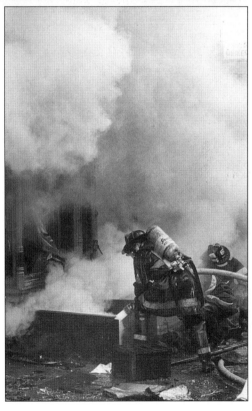

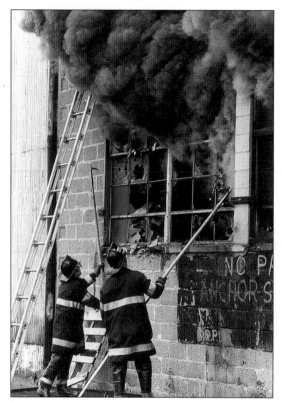

The color and density of the smoke offers the firefighters a clue to the severity of the fire. As water is thrown on a fire, the smoke becomes lighter. When unusual colors of smoke appear, it can indicate that gas or chemicals are feeding the fire. In the fires shown here, there is a potential for a flashover (the instant ignition of superheated air). To the left, firefighters are venting the building to allow the heat, gas, and smoke to dissipate.

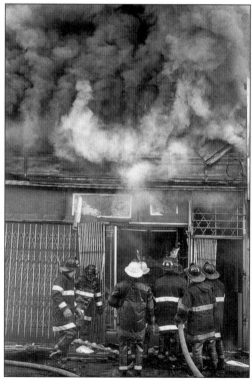

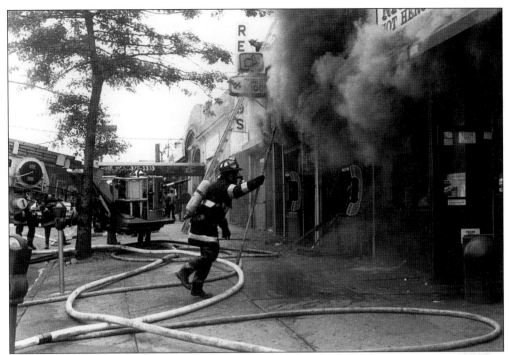

A "taxpayer" for the FDNY is a row of attached stores built on otherwise empty land in order to pay the taxes on the property. Fires in taxpayers usually spread from store to store via their common cockloft, the area between the roof and the ceiling.

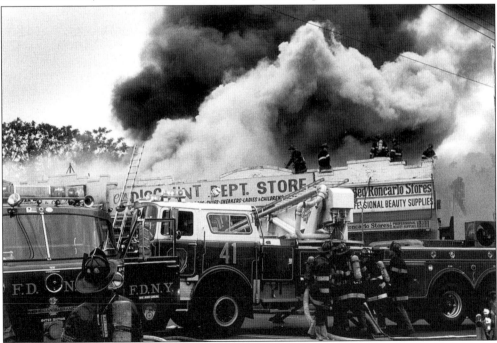

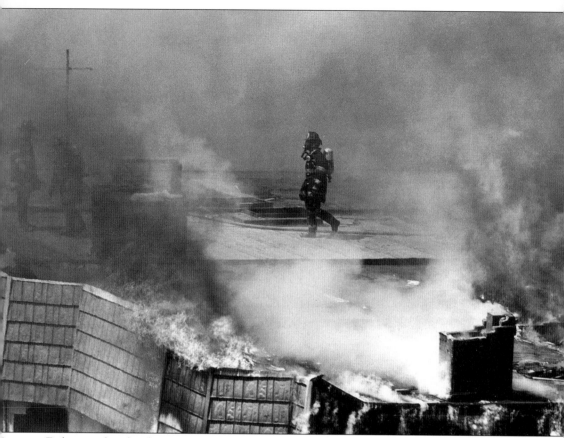

Fighting a fire that has spread to the roof is tricky and particularly dangerous. In August 1978, six Brooklyn firefighters were killed when the burning roof collapsed under them.

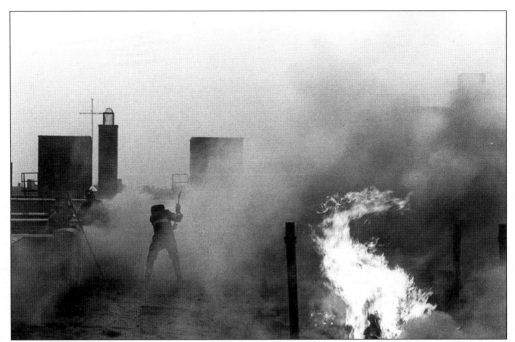

Although it brings them close to the fire, these firefighters have to vent the roof. Chopping holes in the roof allows some of the heat and smoke to escape and helps pinpoint the spread of the fire.

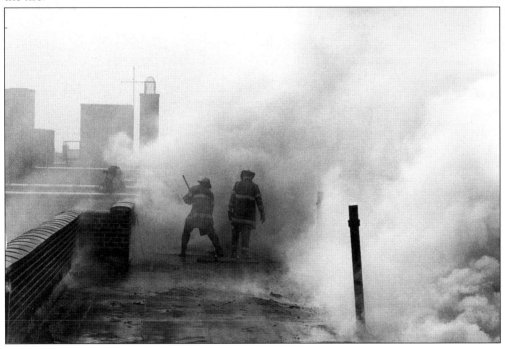

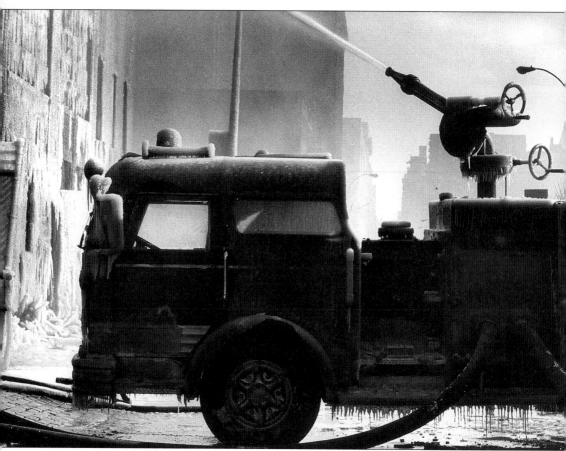

Cold-weather firefighting lends itself to interesting photography but is brutal for the members and their equipment. Often, the hoses and rigs cannot be repositioned because they are frozen in place.

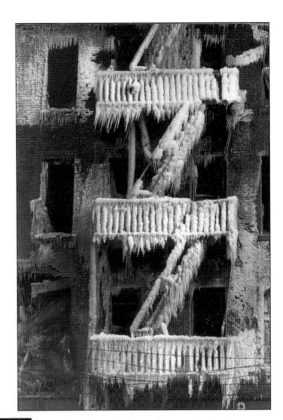

Slips and falls are common while operating at below-freezing temperatures, and hydrants can be rendered inoperable.

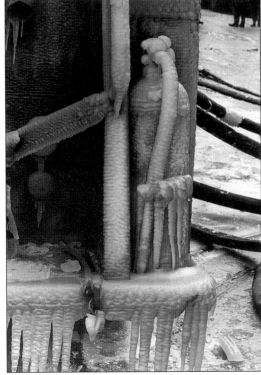

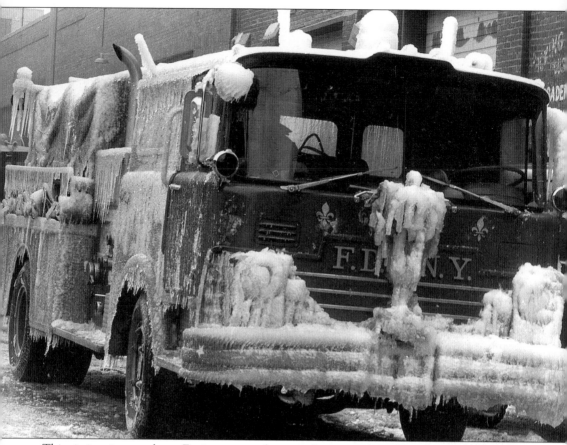

This rig is going nowhere. Equipment on the rig is frozen in place. The department maintains thawing apparatus, which can direct heat to a hydrant connection that is so frozen that the engine cannot disconnect from it.

The department will be at this scene for days to come, and the fire will continue to smolder. The building is too dangerous to enter because of the risk of interior collapses. The ladders and hoselines are frozen in place.

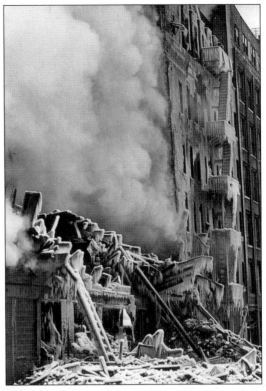

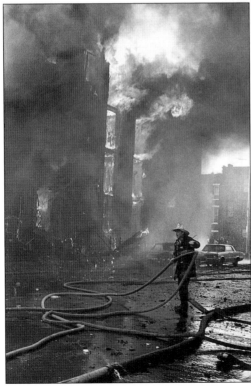

The 1977 blackout was a busy time for the FDNY. In this view, a battalion chief takes matters into his own hands and helps stretch hose at one of the many multiple-alarm fires during the blackout.

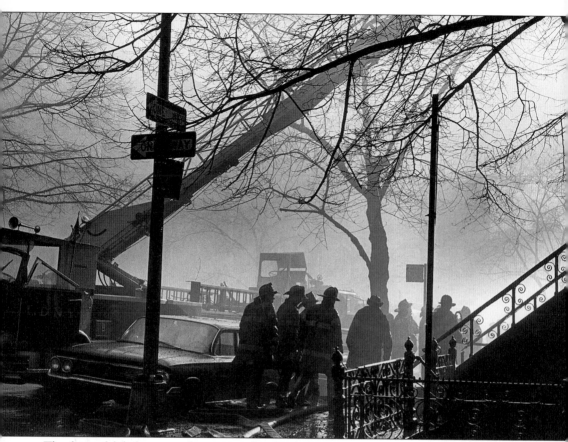

The beautiful lighting at the scene of a fire belies the horror of lost homes and injured firefighters and civilians.

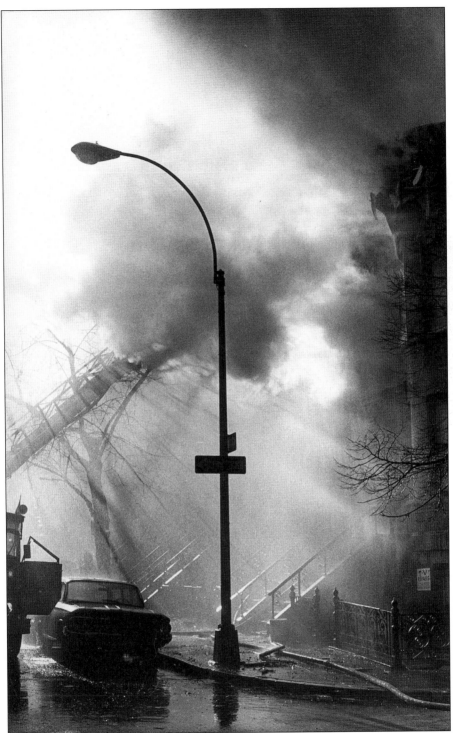

The light filtering through the smoke at a fire produces a surreal effect on the whole neighborhood. Sometimes, enough streams of water are being used to produce a rainbow in front of the fire building.

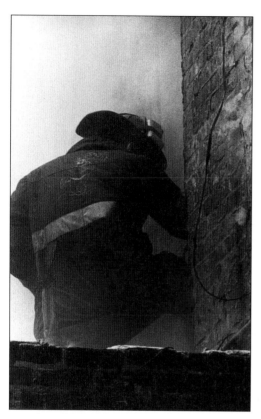

While everyone else is trying to find a way out of a burning building, the firefighters find a way in. Although firefighting requires teamwork, a firefighter sometimes finds himself alone. He keeps in touch by radio, and the officer of his unit keeps track of his movements.

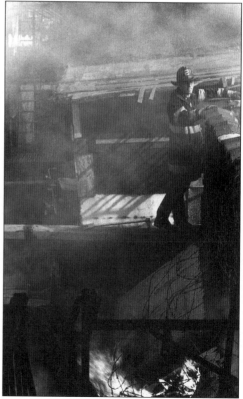

A firefighter watches to make sure he is clear of the collapse zone at a factory fire.

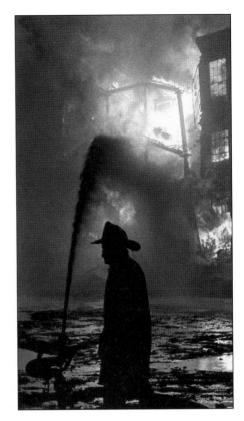

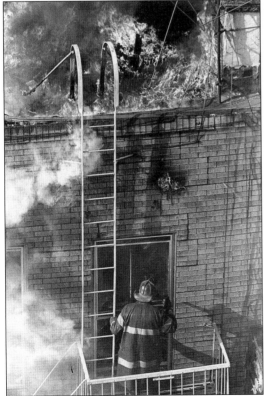

As the fire burns above him, this firefighter is about to enter an apartment to make sure the occupants are out.

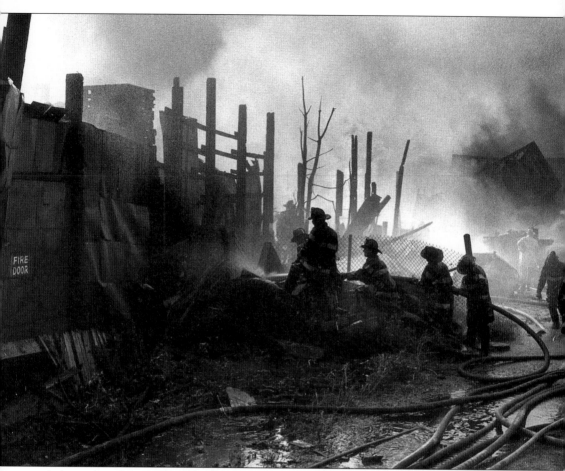

A three-alarm fire at a Brooklyn lumberyard evokes the image of a battlefield. It will take a few firefighters to keep together and handle the fully charged and operating hoseline. The officer is right in there, directing his company.

These firefighters are trying to get close enough to fight the fire while keeping their distance from the extreme heat. Two can be seen wearing their helmets backwards to protect their faces.

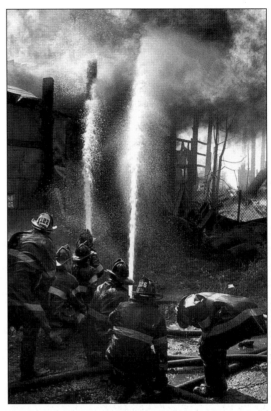

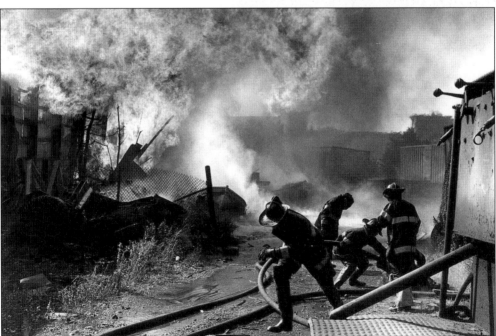

As in a military battle, there are moments of advancement and moments of retreat. In this case, the wind has shifted and the heat has blown back.

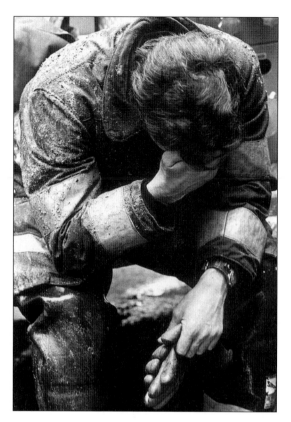

Even if the firefighter is not injured at a fire, the job can be utterly exhausting. Carrying a breathing tank and tools and wearing a mask, helmet, turnout coat, and boots, the firefighter exerts himself even before entering a burning building. The heat, smoke, and stress then take their toll.

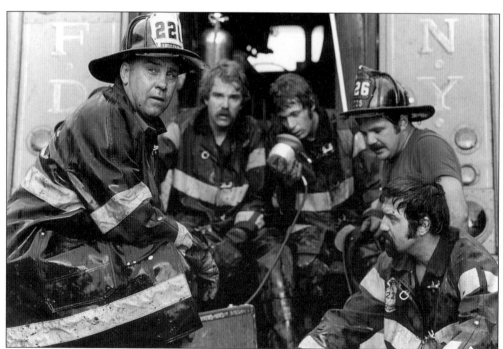

As they are a team during the battle, they remain a team during their rest and recuperation period.

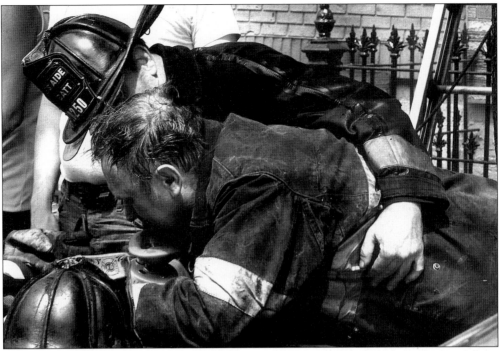
Just as important as fighting the fire is helping a firefighter who has been injured.

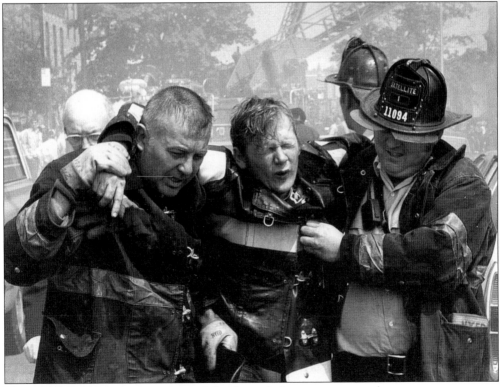
These firefighters are not going to wait for the ambulance to come to them.

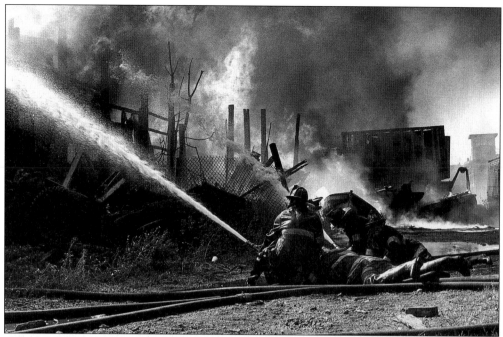

At a Brooklyn lumberyard, firefighters battle heat and struggle to control the fully charged hoseline. They have regained their forward position after retreating earlier.

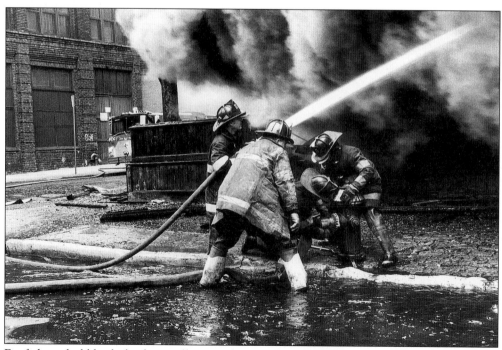

Firefighters hold back the fire to allow another to adjust the hydrant connection.

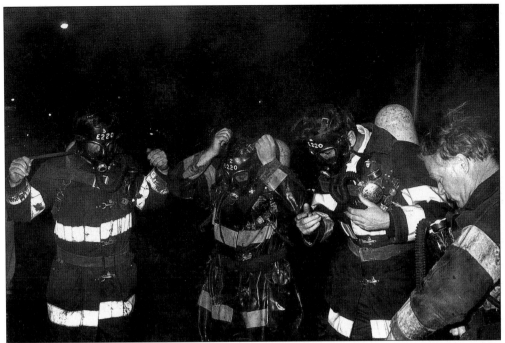

Firefighters adjust their Scott Air-Paks, which allow them to breathe in a smoke-filled area. The tanks contain compressed air, not pure oxygen, as some believe. This nighttime scene evokes the words of Napoleon Bonaparte: "Two o'clock in the morning courage: I mean unprepared courage."

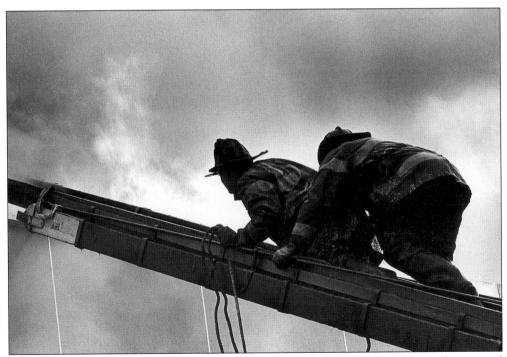

Two firefighters approach the fire on a roof via an old-style wooden aerial ladder, no longer used by the FDNY. In some cases, the ladder itself would catch fire.

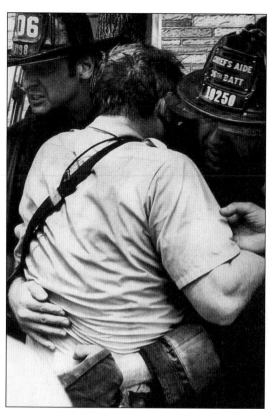

Firefighters are not afraid to show emotion when another is injured.

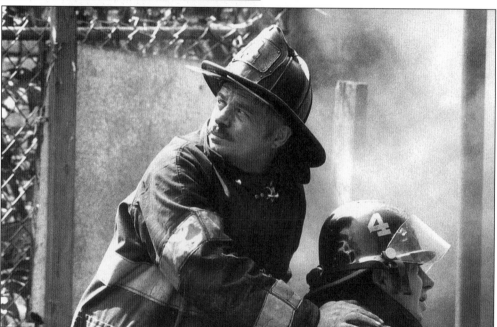

The FDNY frequently tests new equipment designs in the field. This view shows firefighters trying a new helmet (right). Although the department has tested the styles and materials for helmets, the traditional leather has prevailed.

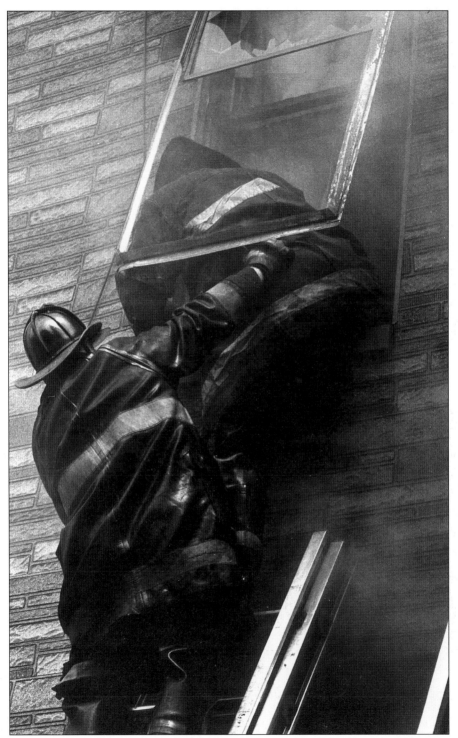

A firefighter helps another on a portable ladder to get into a burning house in order to search for victims. Although difficult to negotiate while wearing 50 to 75 pounds of equipment, the portable ladders are fast and easy to employ.

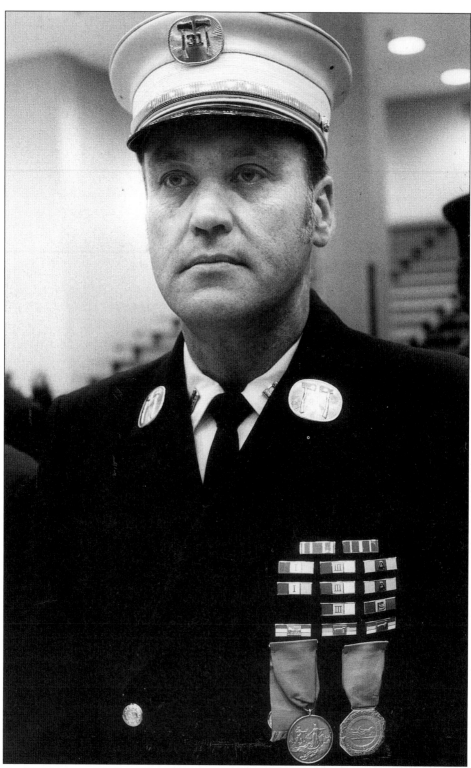

At the FDNY's annual Medal Day, a modest captain has received more medals for valor.

This man's face is expressive of the grief that a firefighter feels after having attended countless funerals.

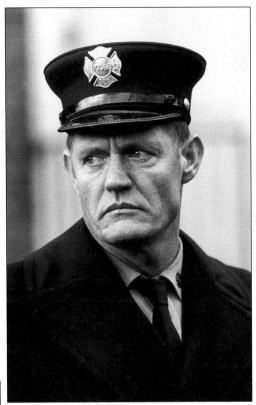

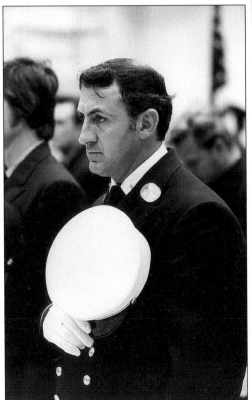

An unidentified lieutenant is pictured on Medal Day. Members of the FDNY take their loyalty to their country seriously.

Firefighters are always keenly aware of the sacrifices that others have made and that they are prepared to make.

Many boys and girls grow up as the proud children of firefighters. Members of the FDNY often come from different generations of one family.

Despite the dirt, this firefighter seems happy to be at war with the red devil.

Providing food and other emergency services at major fires and disasters, the Salvation Army and the Red Cross are welcome sights to victims and firefighters alike. Nothing tastes better than Red Cross beef stew at a fire in the middle of winter.

A firefighter is pictured with the basic tools of his trade—the ax and the Halligan tool. Invented by FDNY firefighter Huey Halligan, it is now used world-over to get past locked doors.

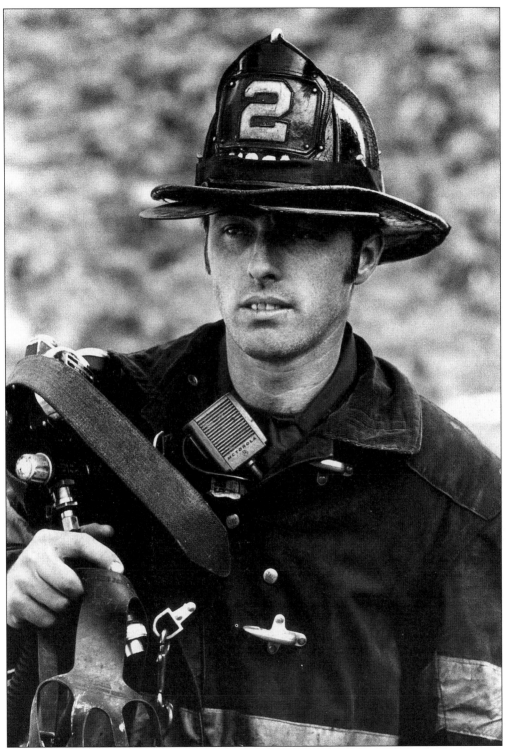

The members of the FDNY's five rescue companies consider themselves as being part of an elite force. This member is carrying his Scott Air-Pak (breathing mask).

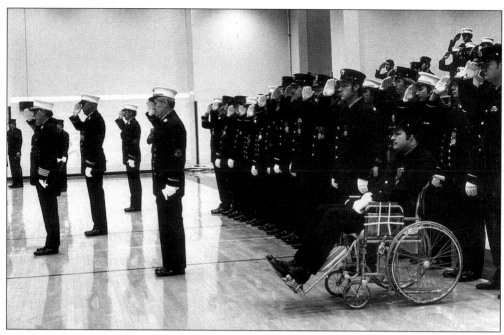

At the department's annual Medal Day, the fire commissioner and the mayor present medals for bravery during the previous year. Each member receiving a medal usually has the rest of the company there to cheer him on. There are many parties in the hours after a Medal Day ceremony.

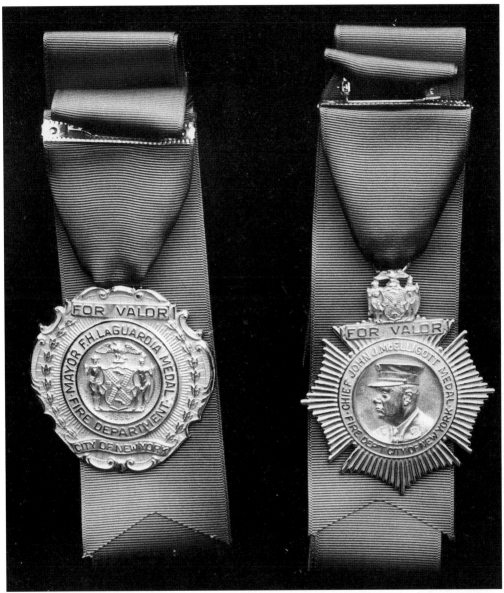

More than 60 different medals for valor are given, endowed over the years by individuals and organizations. These two—the Mayor Fiorello LaGuardia Medal and the Chief John McElligott Medal—have been awarded since 1937.

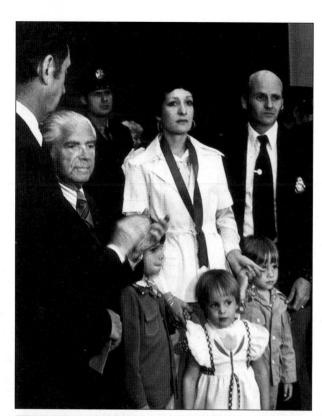

The toughest medals to present are the posthumous ones.

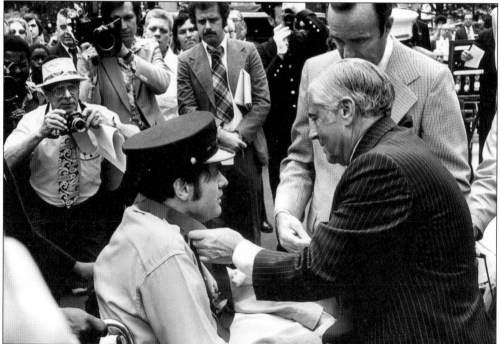

Mayor Abraham Beame joins Fire Commissioner John T. O'Hagan in awarding medals as the press records the moment.

94

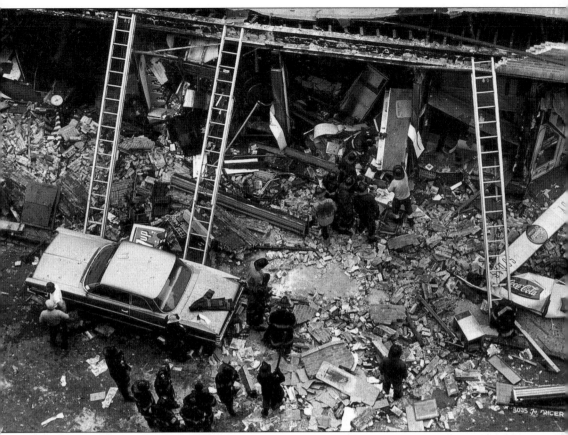

The department is called to all types of emergencies. In this view, a gas leak at a Bronx laundromat has created an explosion that has knocked down the fronts of all the stores on the block.

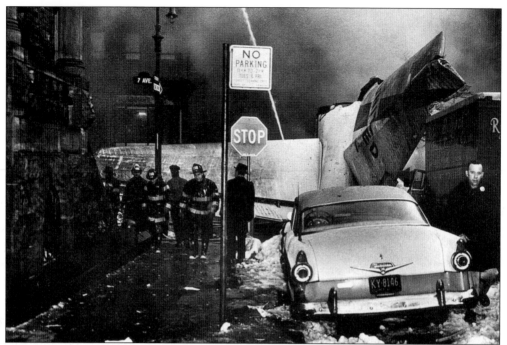

The tail section is all that remains of the plane that crashed into a Brooklyn intersection in December 1960. Because of the blowing snow at the time, the driver of the first engine to arrive thought a truck was on fire. When the wind shifted, he could see the tail section of the plane. The officer radioed for a fifth alarm.

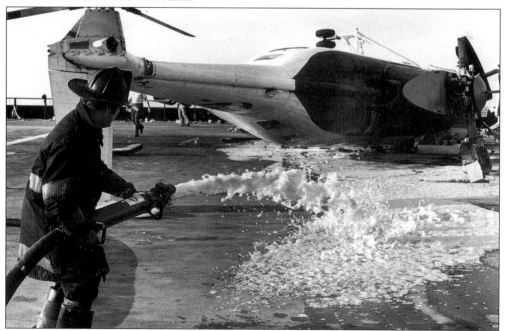

This passenger helicopter crashed while attempting to take off from the roof of the Pan Am Building in 1977. Unlike cellar fires, where foam is used in an attempt to smother the fire, it is used here to prevent a fire.

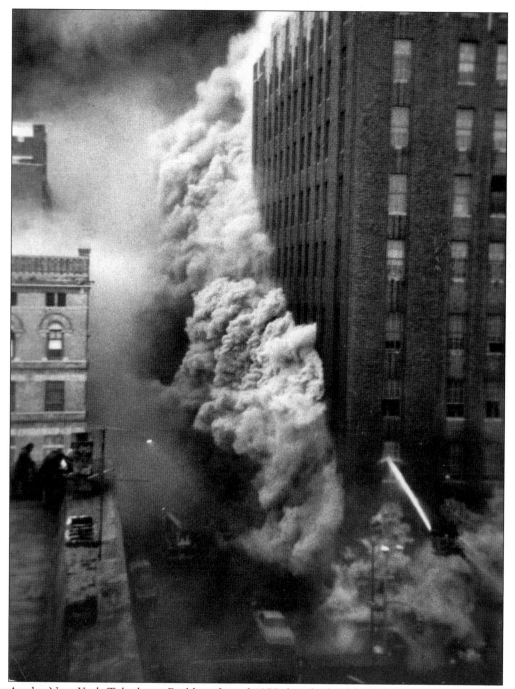

At the New York Telephone Building fire of 1975, hundreds of firefighters were injured and sick for months afterward from the burning wire insulation. The fire knocked out wide areas of phone service as well.

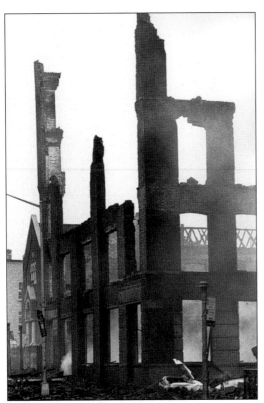

All cities have conflagrations. In July 1977, a Brooklyn fire destroyed 20 buildings, claiming two blocks of commercial and residential buildings. New York's Great Fire of 1835 wiped out the financial district and threw the country into a depression.

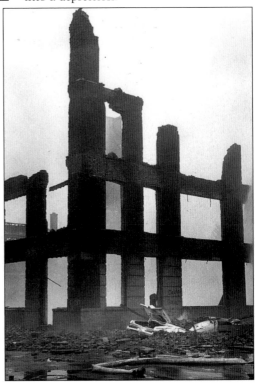

The Brooklyn conflagration of July 1977 has destroyed most of this building. The walls are lying in the middle of the street, burying the cars parked there.

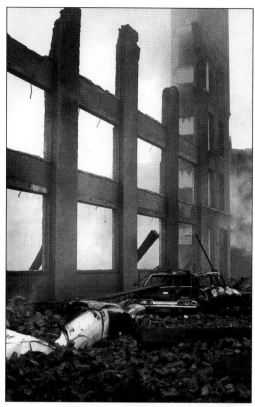

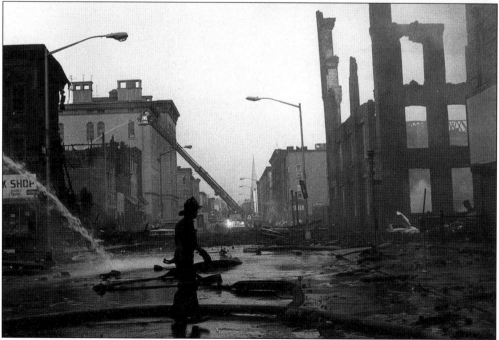

A common sight at conflagrations is the fire jumping streets. Radiant heat also destroys adjacent structures.

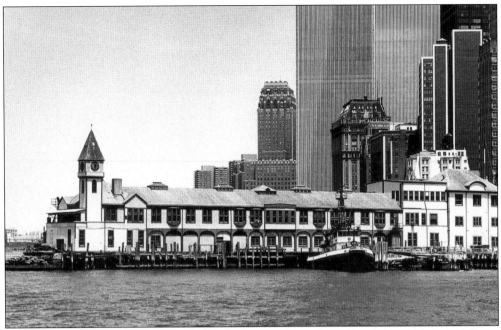

The historic fireboat *Pier* A is pictured with the World Trade Center in the background. For decades, tickertape parades would start up to Broadway from here, usually with the honoree arriving by boat.

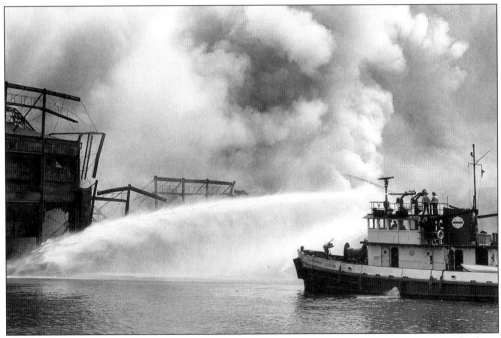

When so many streams of water are used by a fireboat, the force will sometimes cause the boat to drift away. An opposing stream must be set up to counteract the force.

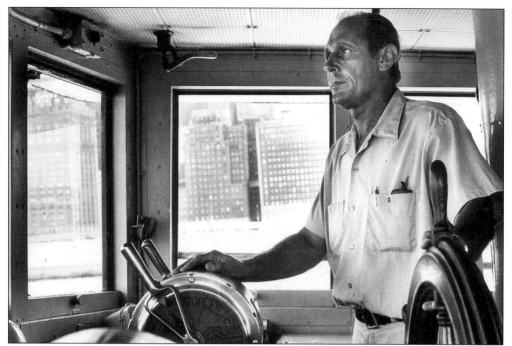

There are some unusual ranks in the FDNY. Pictured is Marine Pilot Aldo Anderson, who went on to become a captain in the Army Corps of Engineers.

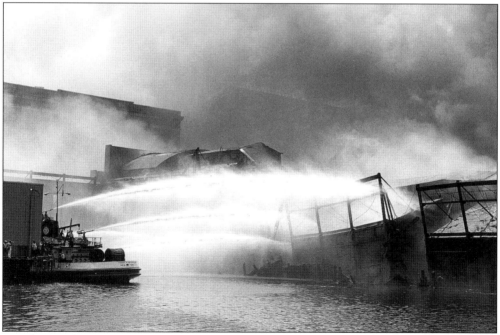

New York in the 1940s and 1950s was a world-class maritime shipping center, with hundreds of piers lining the Hudson and East Rivers. A combination of truck shipping, airline travel, and a failure to keep up the piers led to the destruction and disappearance of most of them. In this image, one of the last ones meets its fate.

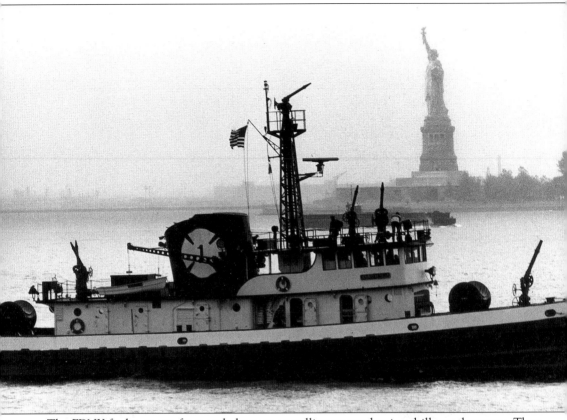

The FDNY fireboats can frequently be seen patrolling or conducting drills on the water. They are always present for events on or near the water, such as regattas or fireworks.

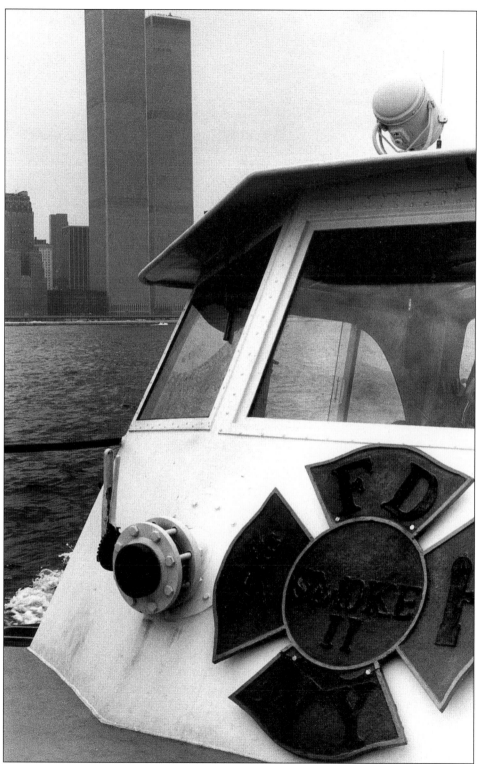

The small fireboat *Smoke II* on the Hudson River passes the World Trade Center.

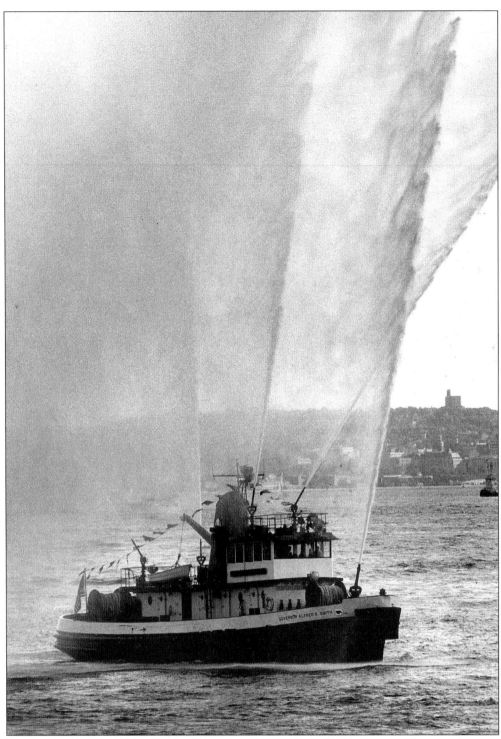

The fireboat *Governor Alfred E. Smith* puts on a display. Such displays are used for special events on the water. The fireboat is capable of simultaneously shooting streams of red, white, and blue water, using an ingenious system of introducing dyes into the nozzle streams.

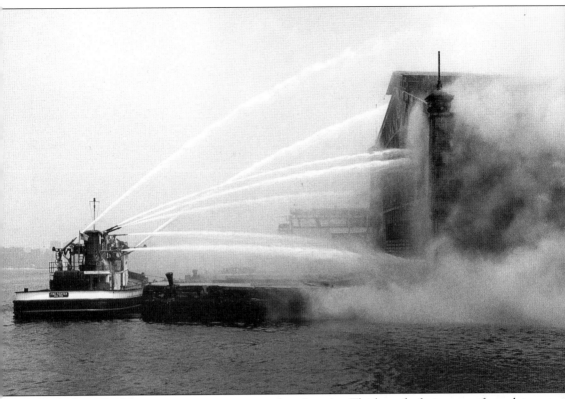

The fireboat *Firefighter* uses seven streams on a burning pier. The boat drafts its water from the river. A gate screens debris from the intake, but fish can sometimes be drawn in and are occasionally seen flying out with the stream.

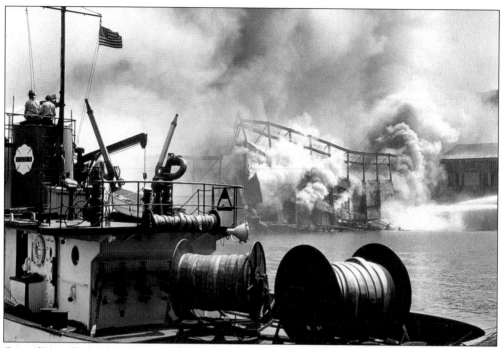

One of New York's last piers on the Hudson River goes under in the 1970s.

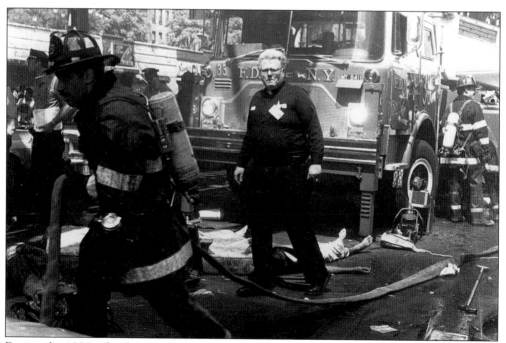

During the 1980s, the department was faced with fires in illegal after-hours clubs. This Bronx club fire killed six. The worst of the fires, at a club called the Happy Land, killed 87.

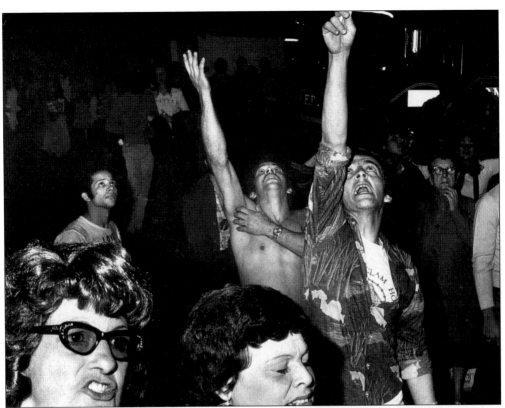

Weegee (Arthur Fellig), a 1940s New
York photographer, often took pictures of
spectators at fires, believing that part of
the story was in their faces. These images
show his influence on this photographer.

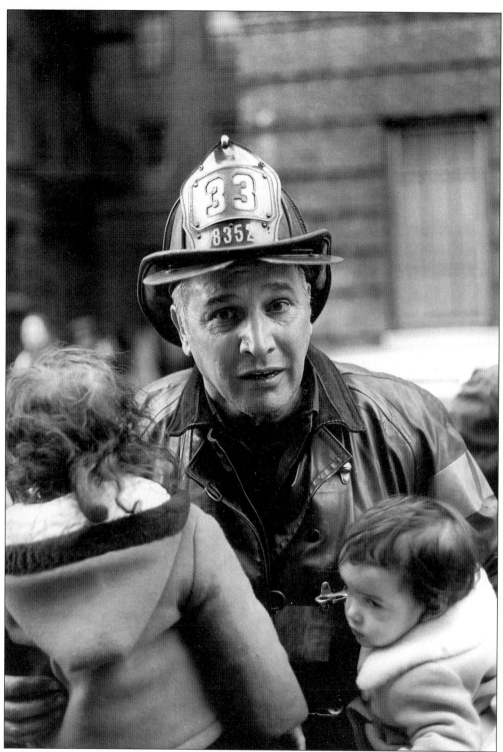

A firefighter is too occupied with the job at hand to reflect on his rescue until he is out of the building.

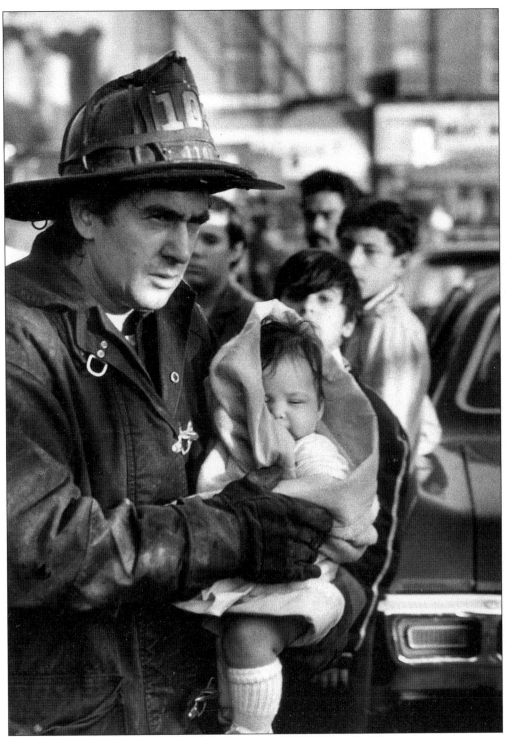

Probably the most gratifying thing a firefighter can do is to rescue a child.

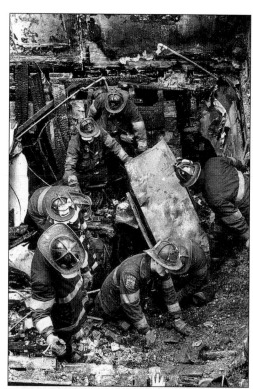

Firefighters search for the remains of a civilian victim of a house fire in Borough Park, Brooklyn.

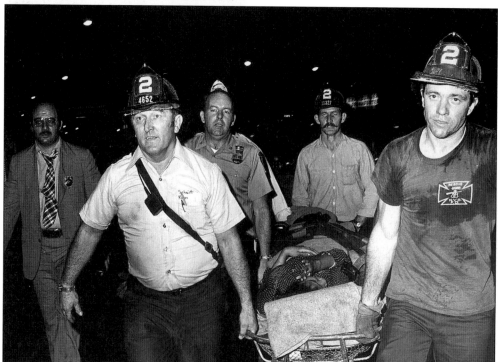

The FDNY works with other emergency agencies at incidents. In this photograph, firefighters, police, and EMS workers remove a victim from a subway incident.

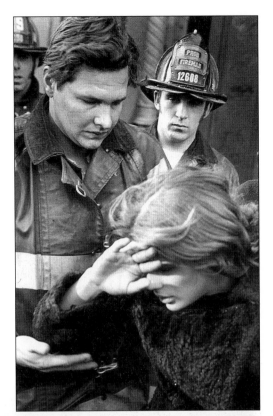

Long before the merger of New York's Fire and Emergency Medical Services, the members of the FDNY were practicing first-responder medical care. Many members trained in CPR on their own time and at their own expense.

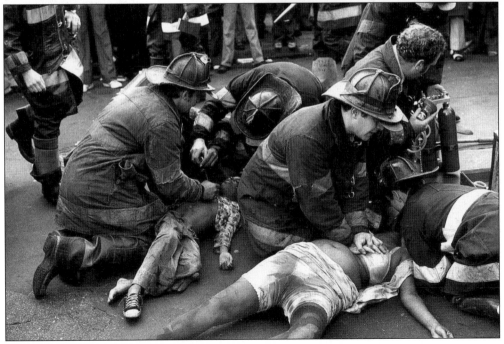

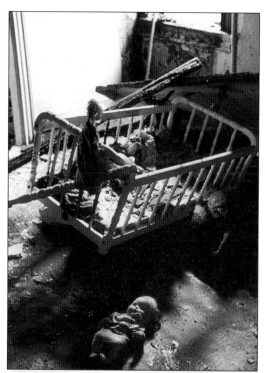

It is particularly tragic when a youngster is a fire victim. Firefighters searching for a child in a crib sometimes find a doll. Sometimes they find dogs, cats, or other pets.

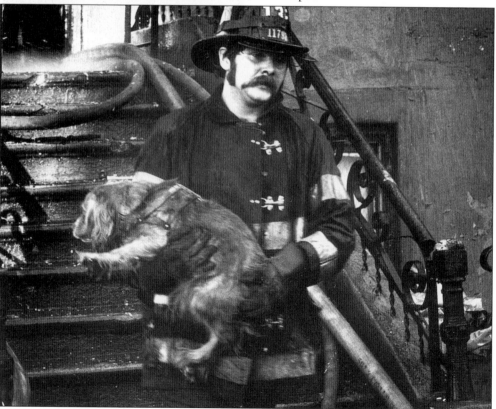

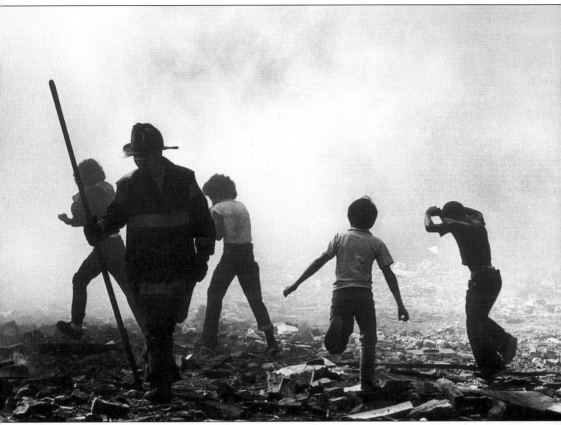

When the urban areas of the United States were burning in the 1960s and 1970s, a fire was just one more playground for ghetto youngsters. At this Bronx fire, the kids were just playing, but objects were sometimes thrown at the fire apparatus from rooftops.

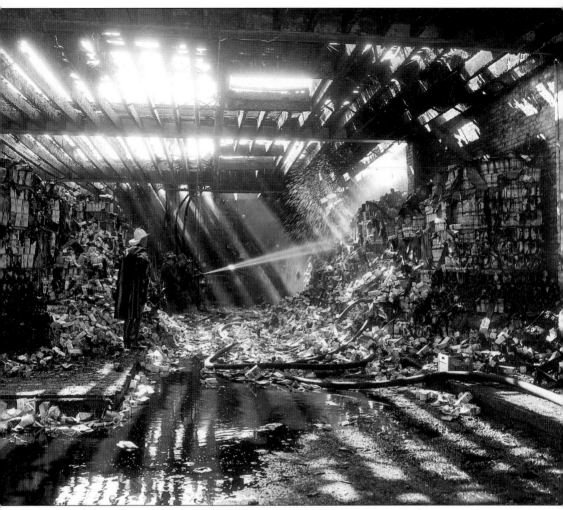

This two-alarm fire at the Gold Medal Farm Dairy gives a preview of what was to become of the South Bronx decades later, when a combination of deteriorating structures and economic upheaval led to fires that devastated entire neighborhoods.

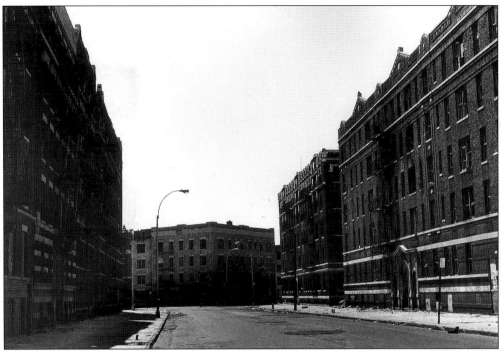

The destruction by fire made some sections of the Bronx seem as if there were no signs of life for blocks. Politicians for 20 years would announce from this spot their plans for the rebuilding. Today, two-story private houses fill the area.

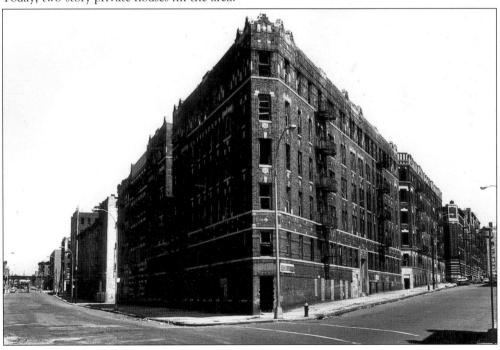

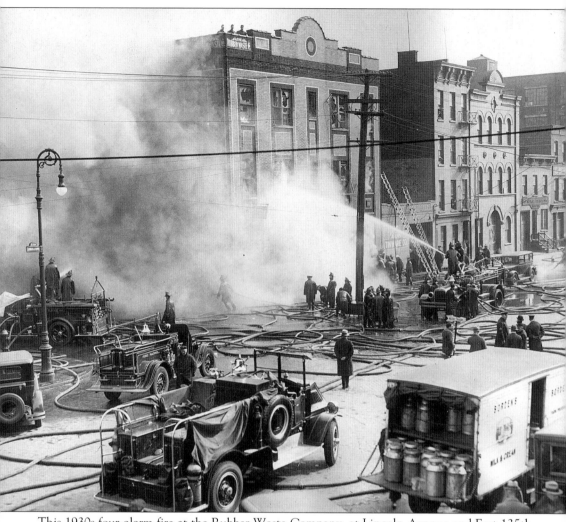

This 1930s four-alarm fire at the Rubber Waste Company, at Lincoln Avenue and East 135th Street in the South Bronx, shows the cycle found in many cities. First, country houses are built, followed by multiple residences and improved transportation. With improved commerce, populations grow. The middle class then moves out and is replaced by the poor. Fires and destruction follow, but then there is a rebirth.

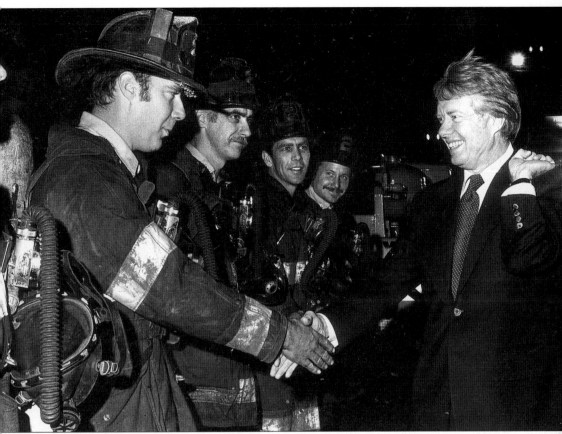

Whenever a president of the United States lands in New York City, a full first-alarm assignment of personnel and equipment is on hand for his safety. In this view, members of Rescue 2 meet Pres. Jimmy Carter.

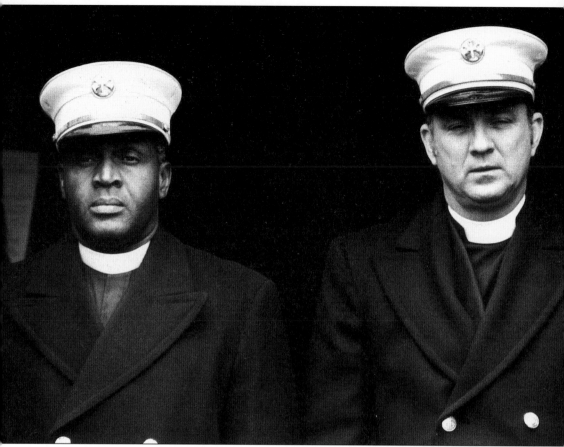

Chaplains Wilford Callender and Alfred Thompson attend a line-of-duty funeral. The FDNY has five or six chaplains of various faiths to minister to the needs of its members. One chaplain was once asked to describe how he would tell a family that a firefighter had died. He replied that he never had to say anything—the family simply knew what had happened as soon as the chaplain walked in the door.

If the line-of-duty funeral for a member takes place near the member's firehouse, the cortege will pass in front.

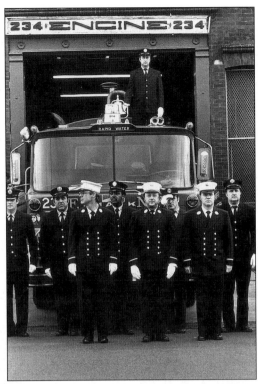

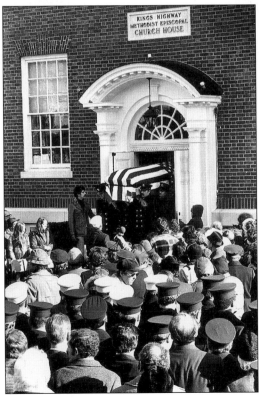

Often, local residents and firefighters from hundreds of miles away attend the funeral of a firefighter killed in the line of duty.

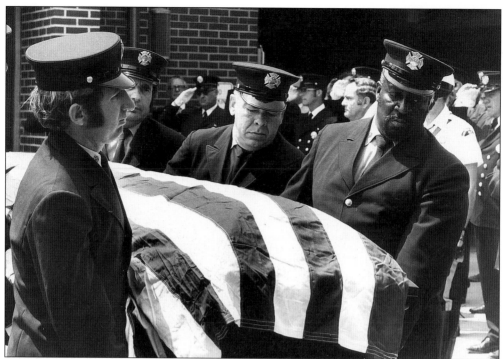

Fire department regulations read, "When the need arises for a detail as a pallbearer, Division Commander shall select a member who has had military experience and has military bearing. Such members shall range in height from 5'10" to 6'2.'"

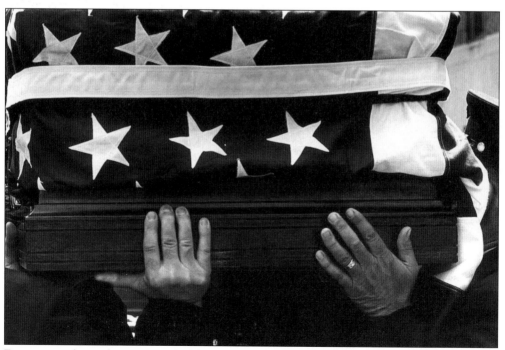

Every move shows the care one firefighter has for another.

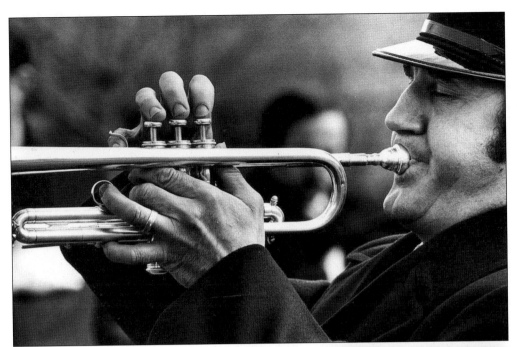

The FDNY functions in many ways as the military would. Here, the playing of taps by a firefighter and the muffled drums evoke the honors given to warriors past.

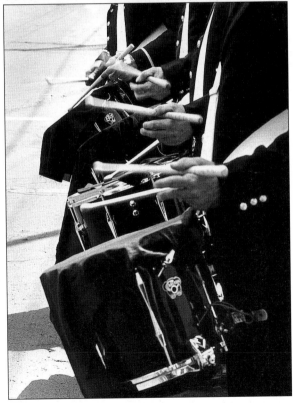

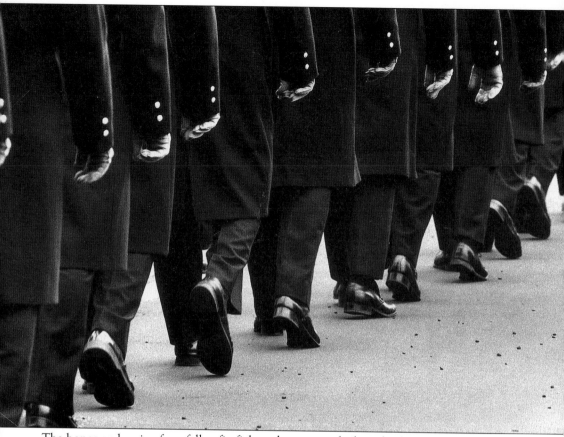

The honor and caring for a fallen firefighter does not end when the funeral is over. The family of a firefighter killed in the line of duty becomes part of the larger family of the FDNY. From household chores to scholarships for the children, the larger FDNY family is always there for the survivors.

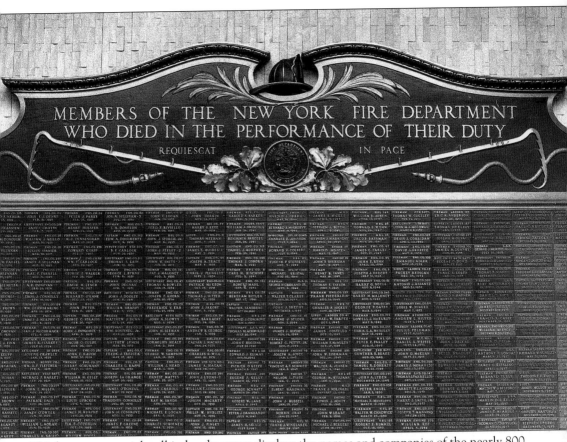

This bronze memorial wall in headquarters displays the names and companies of the nearly 800 members of the FDNY who had died in the line of duty since 1865. After September 11, 2001, the wall was taken down to add another 343 names.

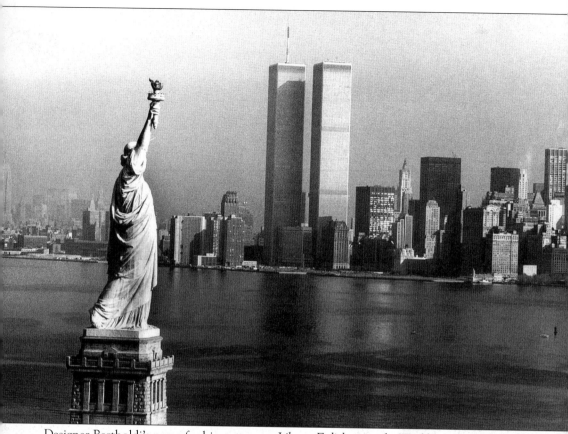

Designer Bartholdi's name for his statue was *Liberty Enlightening the World*.

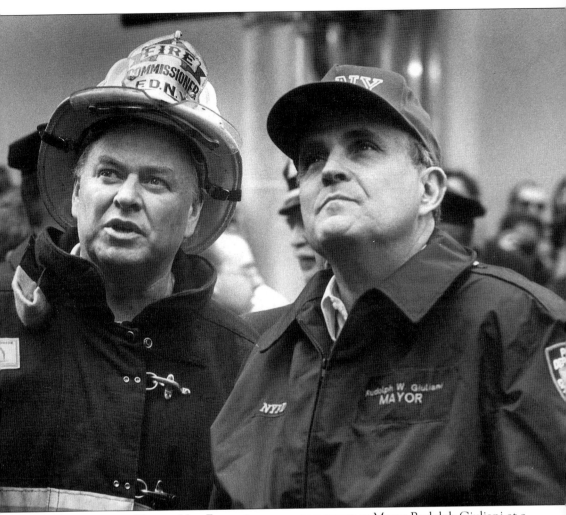

Fire Commissioner Thomas Von Essen gives a progress report to Mayor Rudolph Giuliani at a five-alarm fire in Manhattan on Easter Sunday 1998.

Three

SEPTEMBER 11

Dutch trader Adriaen Block's ship *Tiger* ran aground in lower Manhattan in 1613. The encampment where he and his crew spent that winter ultimately became New York City. On this very site in the 1970s, the World Trade Center was built to represent America's aspirations to new heights, literally and symbolically, and to do so twice with twin towers. It was no coincidence that the restaurant near the top of the north tower was called Windows on the World.

The firehouse for FDNY Engine Company 10 is directly across the street from the World Trade Center. On the morning of September 11, the night shift was going off duty, and the day shift was arriving a little before nine. A radio message from Engine 10 to the Manhattan dispatcher began the day of horror for the FDNY. The report of a plane hitting the north tower of the World Trade Center still held the hope that it had been a small plane—a tragedy for sure but one with a handful of casualties. When a second aircraft struck the south tower shortly thereafter, Engine 10 understood that what was transpiring was much more sinister than a mere accident.

Because many alarms had been requested by chief officers early in the attack, fire apparatus was arriving in a steady, frenetic stream. The arriving firefighters found chaos but immediately rushed into the burning towers. Some of the department's highest-ranking officials had been standing with the fire commissioner and the mayor surveying the scene not 10 minutes before they were killed. Although most firefighters who died were already in the buildings, leading people out, many were just climbing out of their trucks when the 110-story buildings fell on them. Buried and crushed fire engines later had to be pulled out by cranes. By nightfall, lighting had been set up, and the smoking ruins covered with the hundreds of rescuers made for an unearthly tableau.

The twin towers were a powerful symbol and, to some, a powerful target. Since 1613, the site where the World Trade Center once stood has been an integral part of the history of New York City. Since September 11, it has become a place known for unprecedented horror and unparalleled bravery. The lives of an estimated 25,000 people were saved that day by members of the FDNY, including 343 active and retired members who died in the performance of their duty.

Members Lost at the World Trade Center

First Deputy Commissioner William Feehan, Chief of Department Peter J. Ganci Jr., Citywide Tour Commander Gerard Barbara (assistant chief), Citywide Tour Commander Donald Burns (assistant chief), Rev. Mychal Judge (chaplain), Fire Marshal Ronald Bucca, Carlos Lillo (paramedic), and Ricardo Quinn (paramedic).

Battalion Chiefs

Dennis Cross, Thomas DeAngelis, Dennis Devlin, Raymond Downey, John Fanning, Edward Geraghty, Joseph Grzelak, Thomas Haskell Jr., Charles Kasper, Joseph Marchbanks Jr., William McGovern, John Moran, Orio Palmer, John Paolillo, Richard Prunty, Matthew Ryan, Fred Scheffold, Lawrence Stack, and John Williamson.

Captains

James Amato, Daniel Brethel, Patrick Brown, Vincent Brunton, William Burke Jr., Frank Callahan, James J. Corrigan, Martin Egan Jr., Thomas Farino, Joseph Farrelly, John Fischer, Terence Hatton, Brian Hickey, Walter Hynes, Frederick Ill Jr., Louis Modafferi, Thomas Moody, William O'Keefe, Vernon Richard, Timothy Stackpole, Patrick Waters, and David Wooley.

Lieutenants

Brian Ahearn, Gregg Atlas, Steven Bates, Carl Bedigian, John Crisci, Edward Datri, Andrew Desperito, Kevin Donnelly, Kevin Dowdell, Michael Esposito, Michael Fodor, Peter Freund, Charles Garbarini, Vincent Giammona, John Ginley, Geoffrey Guja, Joseph Gullickson, Vincent Halloran, Harvey Harrell, Stephen Harrell, Michael Healey, Timothy Higgins, Anthony Jovic, Ronald Kerwin, Joseph Leavey, Charles Margiotta, Peter Martin, Paul Martini, William McGinn, Paul Mitchell, Dennis Mojica, Raymond Murphy, Robert Nagel, Daniel O'Callaghan, Thomas O'Hagan, Glenn Perry, Philip Petti, Kevin Pfeifer, Kenneth Phelan, Michael Quilty, Robert Regan, Michael Russo, Christopher Sullivan, Robert Wallace, Michael Warchola, and Glenn Wilkinson.

Firefighters

Joseph Agnello, Eric Allen, Richard Allen, Calixto Anaya Jr., Joseph Angelini, Joseph Angelini Jr., Faustino Apostol Jr., David Arce, Louis Arena, Carl Asaro, Gerald Atwood, Gerald Baptiste, Matthew Barnes, Arthur Barry, Stephen Belson, John Bergin, Paul Beyer, Peter Bielfield, Brian Bilcher, Carl Bini, Christopher Blackwell, Michael Bocchino, Frank Bonomo, Gary Box, Michael Boyle, Kevin Bracken, Michael Brennan, Peter Brennan, Andrew Brunn, Greg Buck, John Burnside, Thomas Butler, Patrick Byrne, George Cain, Salvatore Calabro, Michael Cammarata, Brian Cannizzaro, Dennis Carey, Michael Carlo, Michael Carroll, Peter Carroll, Thomas Casoria, Michael Cawley, Vernon Cherry, Nicholas Chiofalo, John Chipura, Michael Clarke, Steven Coakley, Tarel Coleman, John Collins, Robert Cordice,

Ruben Correa, James Coyle, Robert Crawford, Thomas Cullen III, Robert Curatolo, Michael Dauria, Scott Davidson, Edward Day, Manuel Delvalle, Martin Demeo, David DeRubbio, Gerard Dewan, George DiPasquale, Gerard Duffy, Michael Elferis, Francis Esposito, Robert Evans, Terrence Farrell, Lee Fehling, Alan Feinberg, Michael Fiore, Andre Fletcher, John Florio, Thomas Foley, David Fontana, Robert Foti, Andrew Fredericks, Thomas Gambino Jr., Thomas Gardner, Matthew Garvey, Bruce Gary, Gary Geidel, Denis Germain, James Giberson, Ronnie Gies, Paul Gill, Jeffrey Giordano, John Giordano, Keith Glascoe, James Gray, Jose Guadalupe, David Haldeman, Robert Hamilton, Sean Hanley, Thomas Hannafin, Dana Hannon, Daniel Harlin, Timothy Haskell, Michael Haub, Philip T. Hayes, John Heffernan, Ronnie Henderson, Joseph Henry, William Henry, Thomas Hetzel, Jonathon Hohmann, Thomas Holohan, Joseph Hunter, Jonathon Ielpi, William Johnston, Andrew Jordan, Karl Joseph, Angel Juarbe Jr., Vincent Kane, Paul Keating, Thomas Kelly, Thomas Kelly (2), Richard Kelly Jr., Thomas Kennedy, Michael Kiefer, Robert King Jr., Scott Kopytko, William Krukowski, Kenneth Kumpel, Thomas Kuveikis, David LaForge, William Lake, Robert Lane, Peter Langone, Scott Larsen, Neil Leavy, Daniel Libretti, Robert Linnane, Michael Lynch, Michael Lynch (2), Michael Lyons, Patrick Lyons, Joseph Maffeo, William Mahoney, Joseph Maloney, Kenneth Marino, John Marshall, Joseph Mascali, Keithroy Maynard, Brian McAleese, John McAvoy, Thomas McCann, Dennis McHugh, Robert McMahon, Robert McPadden, Terence McShane, Timothy McSweeney, Martin McWilliams, Raymond Meisenheimer, Charles Mendez, Steve Mercado, Douglas Miller, Henry Miller Jr., Robert Minara, Thomas Mingione, Manuel Mojica, Carl Molinaro, Michael Montesi, Vincent Morello, Christopher Mozzillo, Richard Muldowney Jr., Michael Mullan, Dennis Mulligan, John Napolitano, Peter Nelson, Gerard Nevins, Denis Oberg, Douglas Oelschlager, Joseph Ogren, Samuel Oitice, Patrick O'Keefe, Eric Olsen, Jeffrey Olsen, Steven Olson, Kevin O'Rourke, Michael Otten, Jeffrey Palazzo, Frank Palombo, Paul Pansini, James Pappageorge, Robert Parro, Durrell Pearsall, Christopher Pickford, Shawn Powell, Vincent Princiotta, Kevin Prior, Lincoln Quappe, Leonard Ragaglia, Michael Ragusa, Edward Rall, Adam Rand, Donald Regan, Christian Regenhard, Kevin Reilly, James Riches, Joseph Rivelli Jr., Michael Roberts, Michael Roberts (2), Anthony Rodriguez, Matthew Rogan, Nicholas Rossomando, Paul Ruback, Stephen Russell, Thomas Sabella, Christopher Santora, John Santore, Gregory Saucedo, Dennis Scauso, John Schardt, Thomas Schoales, Gerard Schrang, Gregory Sikorsky, Stephen Siller, Stanley Smagala Jr., Kevin Smith, Leon Smith Jr., Robert Spear Jr., Joseph Spor, Gregory Stajk, Jeffrey Stark, Benjamin Suarez, Daniel Suhr, Brian Sweeney, Sean Tallon, Allan Tarasiewicz, Paul Tegtmeier, John Tierney, John Tipping II, Hector Tirado Jr., Richard VanHine, Peter Vega, Lawrence Veling, John Vigiano II, Sergio Villanueva, Lawrence Virgilio, Jeffrey Walz, Kenneth Watson, Michael Weinberg, David Weiss, Timothy Welty, Eugene Whelan, Edward White, Mark Whitford, William X. Wren, and Raymond York.

Apparatus Destroyed at the World Trade Center

A total of 92 vehicles, worth $47 million, were destroyed. These included 15 aerial ladder trucks, 18 engine pumpers, 10 ambulances, 16 chief's and EMS SUVs, 23 cars of fire department officials, 3 rescue company vehicles, 1 tactical support unit, 2 high-rise units, 3 squad company vehicles and their associated trucks, 2 emergency repair trucks, 1 satellite engine, and 1 mask service unit truck.

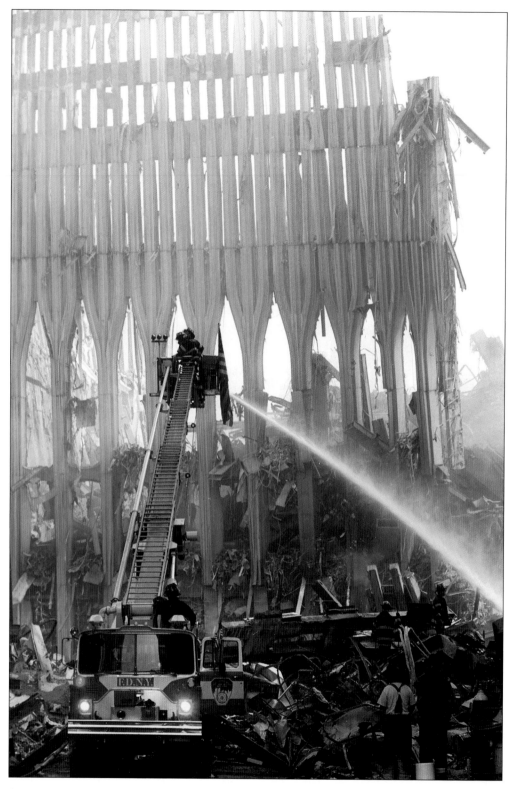

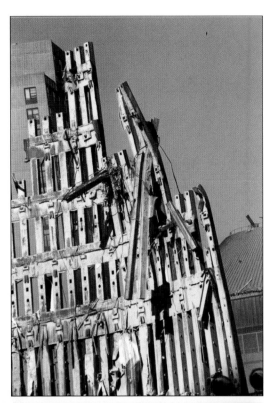

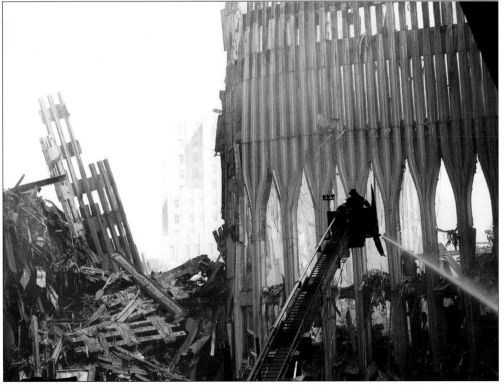

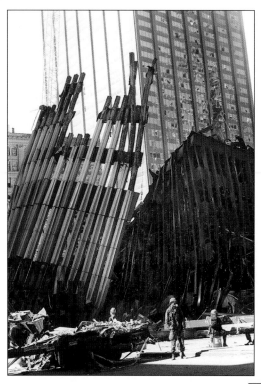

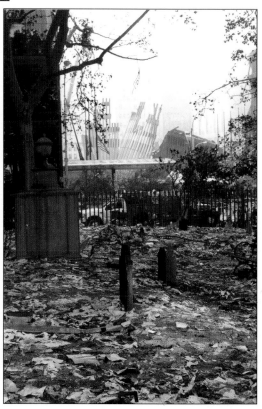

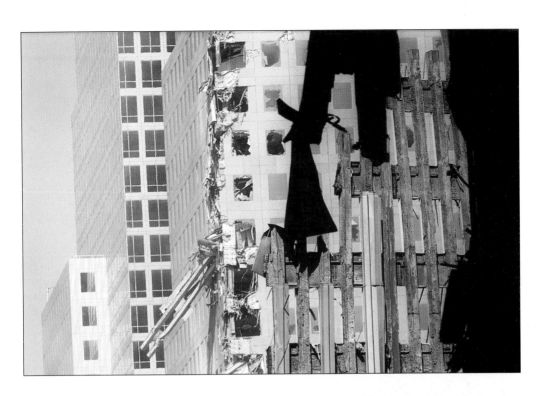

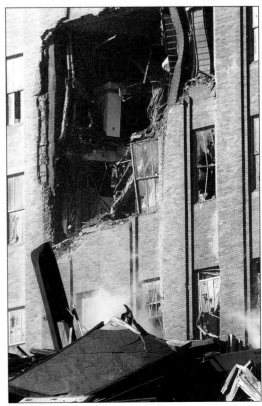

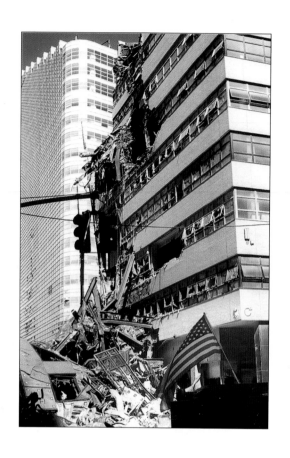

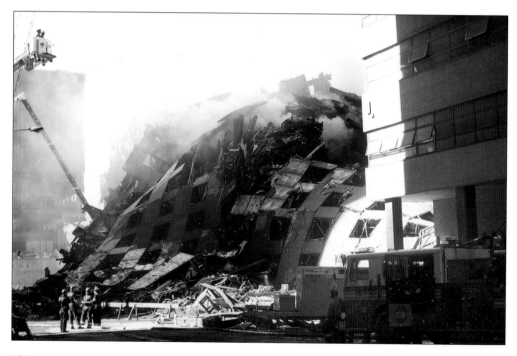

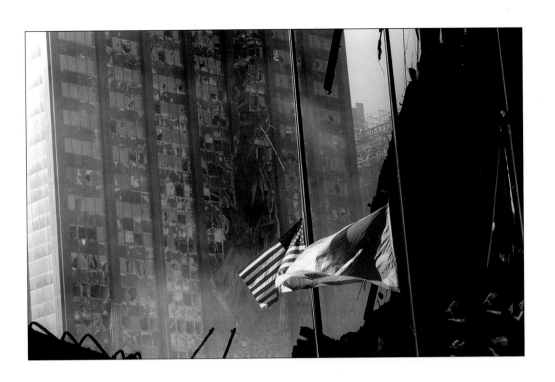

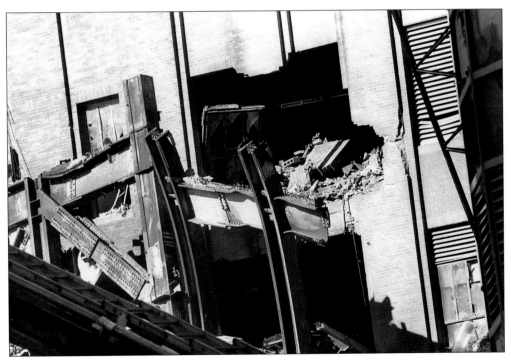

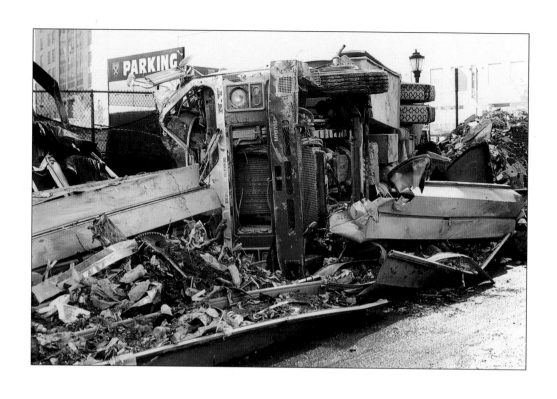

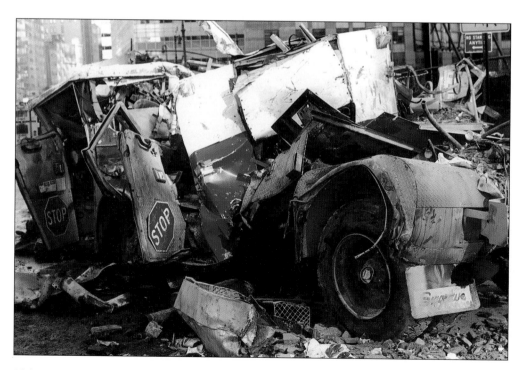

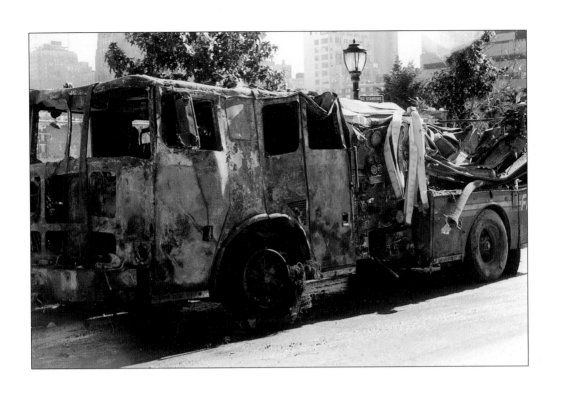

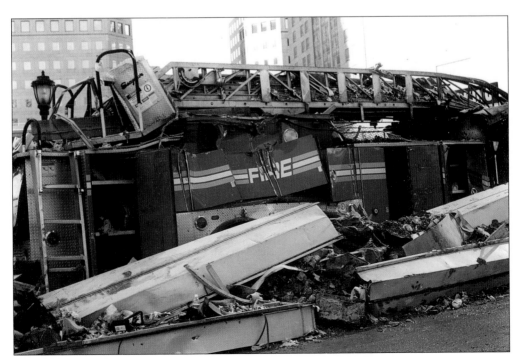

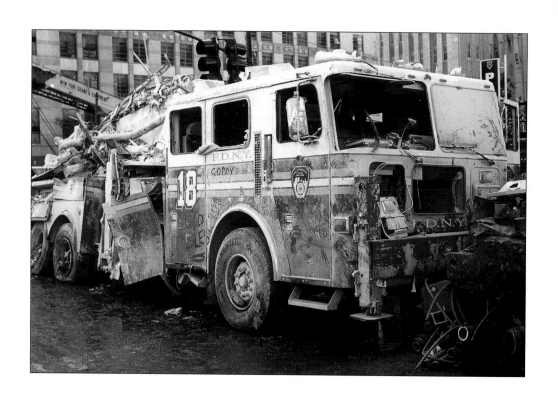

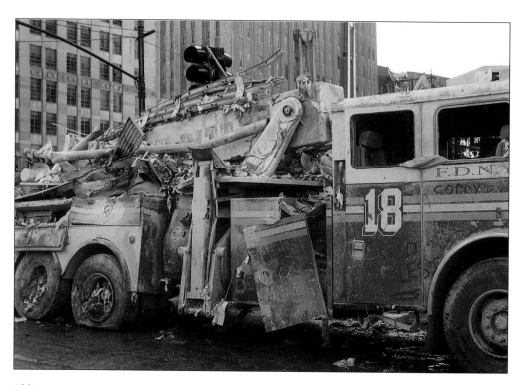

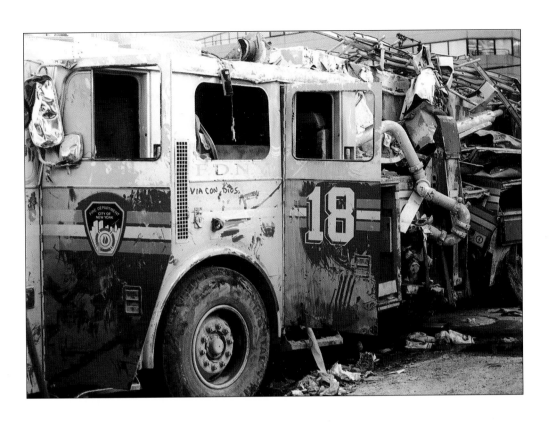

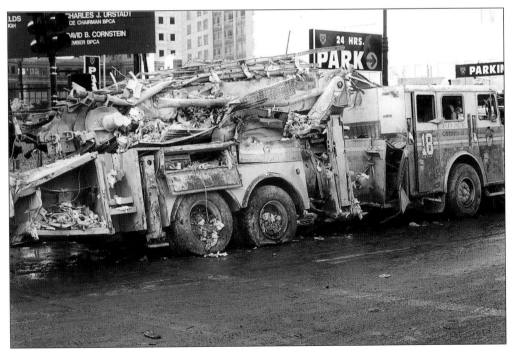

139

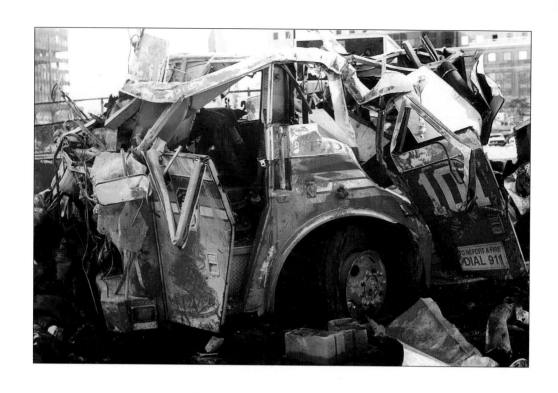

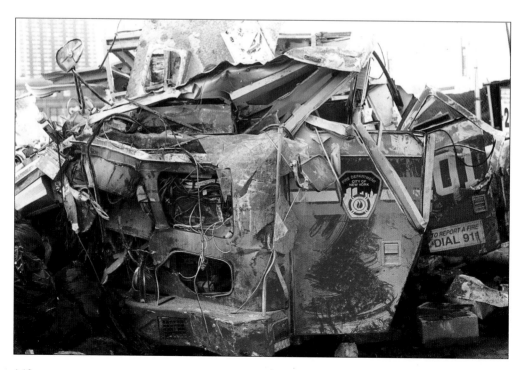

140

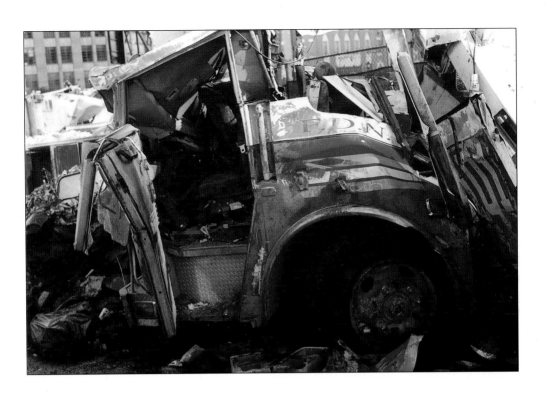

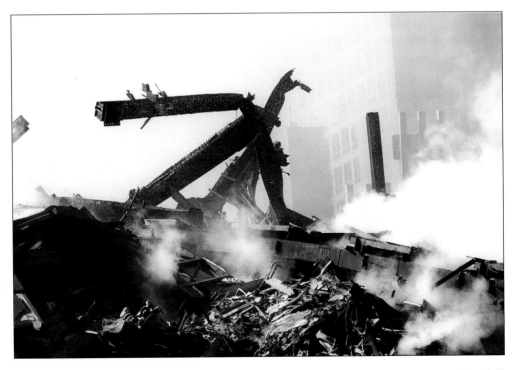

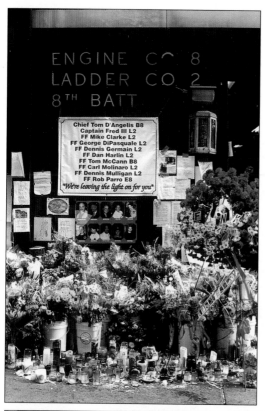

ENGINE CO. 8
LADDER CO. 2
8TH BATT

Chief Tom D'Angelis B8
Captain Fred III L2
FF Mike Clarke L2
FF George DiPasquale L2
FF Dennis Germain L2
FF Dan Harlin L2
FF Tom McCann B8
FF Carl Molinaro L2
FF Dennis Mulligan L2
FF Rob Parro E8

"We're leaving the light on for you"

Many firehouses that had lost members soon found themselves covered with flowers, candles, greeting cards, posters, and drawings made by children. They received visitors almost nonstop in the days following the attack. This firehouse—Engine Company 8 and Ladder Company 2 in midtown—lost 10 members. Some firehouses lost every member working that day. Because of the prime location of Engine 8 and the number of members lost, it was visited by senators, a former president, a prime minister, and hundreds of New Yorkers and tourists.

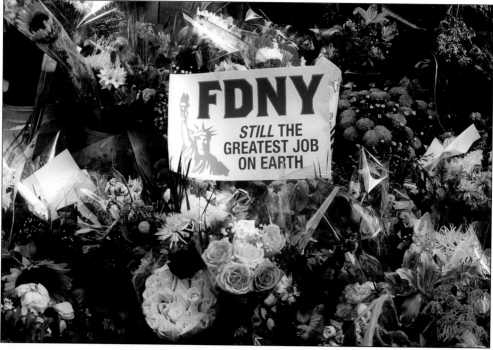

FDNY
STILL THE
GREATEST JOB
ON EARTH

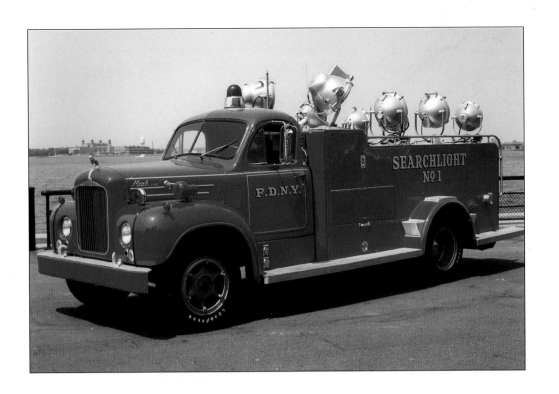

Further Information

Readers interested in the history of the FDNY should visit the New York City Fire Museum, located at 278 Spring Street in Manhattan. The popular searchlight unit, lovingly restored, is one of the many exhibits worth seeing. The fire department's official library is also a wealth of research information. It is the Mand Library at the Randall's Island Training Academy.

Those interested in the history of firefighting in New York City should consult the following sources:

Cannon, Donald J., ed. *Heritage of Flames: The Illustrated History of Early American Firefighting.* Garden City, New York: Doubleday, 1977.

Costello, Augustine E. *Our Firemen: A History of the New York Fire Departments.* New York: A.E. Costello, 1887.

Johnson, Gus. *F.D.N.Y.: The Fire Buff's Handbook of the New York Fire Department, 1900–1975.* Belmont, Massachusetts: Western Islands, 1977.

Kernan, J. Frank. *Reminiscences of the Old Fire Laddies and Volunteer Fire Departments of New York and Brooklyn.* New York: M. Crane, 1885.

Limpus, Lowell M. *History of the New York Fire Department.* New York: E.P. Dutton, 1940.

Fire Department of the City of New York. *WNYF Centennial Issue 1865–1965.* New York: FDNY, 1965.

Sheldon, George W. *The Story of the Volunteer Fire Department of the City of New York.* New York: Harper and Brothers, 1882.

Smith, Dennis. *Report from Engine Co. 82.* New York: McCall, 1972.

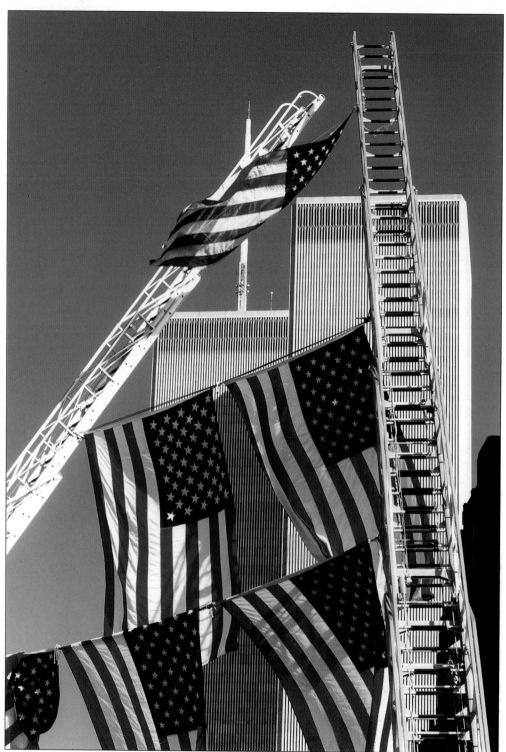

At the Medal Day ceremony held in front of city hall every year, flags are hung from fire department aerial ladders. This photograph was taken one glorious spring day in the early 1990s.